start to
draw

Robert Capitolo
& Ken Schwab

Sterling Publishing Co., Inc.
New York

This book is dedicated to our wives,
Rosemary Capitolo and Jeanne Schwab,
and to our friend and mentor teacher,
John Quigley.

Designed by Shelley Himmelstein
Edited by Isabel Stein

All photographs by the authors
except: page 24 left, 25, 26, and 27 by David Ezra Stein.
Photo on page 24 right by Anne Steinfeld.

Library of Congress Cataloging-in-Publication Data

Capitolo, Robert.
 Drawing course 101 / Robert Capitolo & Ken Schwab.
 p. cm.
 Includes index.
 ISBN 1-4027-0383-X
 1. Drawing--Technique I. Schwab, Ken. II. Title.
NC650.C242 2004
741.2--dc22 2004018627

10 9 8 7 6 5 4 3 2 1

Published in paperback in 2006 by Sterling Publishing Co., Inc.
387 Park Avenue South, New York, NY 10016
Hardcover edition published under the title *Drawing Course 101*
© 2004 by Robert Capitolo and Ken Schwab
Distributed in Canada by Sterling Publishing
c/o Canadian Manda Group, 165 Dufferin Street,
Toronto, Ontario, Canada M6K 3H6
Distributed in the United Kingdom by GMC Distribution Services
Castle Place, 166 High Street, Lewes, East Sussex, England BN7 1XU
Distributed in Australia by Capricorn Link (Australia) Pty. Ltd.
P.O. Box 704, Windsor, NSW 2756, Australia

Sterling ISBN-13: 978-1-4027-0383-6 Hardcover
 ISBN-10: 1-4027-0383-X

 ISBN-13: 978-1-4027-3460-1 Paperback
 ISBN-10: 1-4027-3460-3

For information about custom editions, special sales, premium and
corporate purchases, please contact Sterling Special Sales
Department at 800-805-5489 or specialsales@sterlingpub.com.

Contents

Introduction

From the cave drawings of the Paleolithic down to the present day, drawing has played an important role in the spiritual and artistic life of people. The artists of today have built on the lessons of the masters. They have pushed the boundaries on the use, power, and expressive quality of line drawing, while still controlling its sensitivity. Drawing continues to be a personal creative process.

The intent of this book is to provide detailed suggestions and activities to guide you through a variety of drawing and compositional activities. Drawing is a skill that you can learn, in the same way you learn to ride a bike or shoot a basket. As you use this book, you will find that we focus importance on the creative process, although we take into account the need for a successful end product. We are not presenting formulas for making works of art.

In addition to covering basic drawing concepts in the early chapters, we have given seven projects, with many activities. They will help you to improve your observational, organizational, and expressive skills and your ability to draw and shade. Time, practice, and your creative spirit will influence the quality of the artwork that you produce. We hope you'll find the examples and activities good "jumping-off places" to get into the swim of your own artistic life.

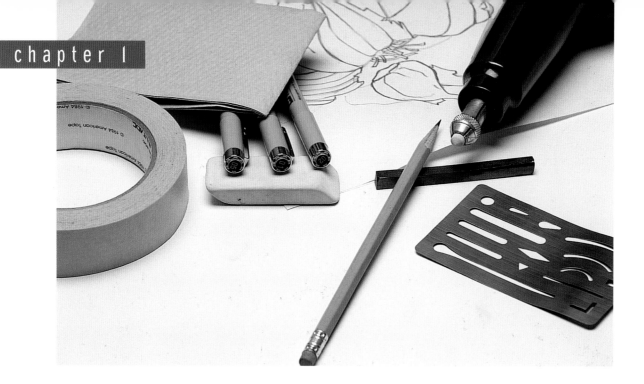

Materials and Tools

There is an incredible variety of drawing materials available, but successful drawings can be made using very simple and inexpensive supplies, so start with the basics. Here is a brief survey of the basic things you'll need to do the projects in this book. See each project for details.

Pencils

The graphite ("lead") pencil we use today is a fairly recent addition to the drawing tools of the artist. The Greeks and Romans used a lead disk to draw guidelines on papyrus. The word "pencil" comes from the Latin *pencillus,* which means "little tail." It originally referred to a thin brush. During the 14th century, thin rods of lead were placed inside wooden encasements, forming the first pencils. The 14th-century pencil did not write or draw very well. It was not until 1564, when a graphite ore deposit was discovered, that our present-day pencil was developed. For drawing, the graphite was formed into a sharp-pointed dowel shape and was wrapped with string to keep the fingers clean. In the 18th century, a metal holder called a *port-crayon* was intro-

duced for the same purpose. In 1795, Nicolas Jacques Conté, a Frenchman, invented the conté crayon because there was a shortage of graphite during the Napoleonic wars. The conté crayon consisted of powdered graphite and clay. Today it is actually a variety of fabricated chalk. Conté found that varying the proportions of graphite and clay would produce the range of soft to hard graphite pencils that we use today.

The present-day graphite pencil has a hardness range from the hardest at 9H to the softest at 6B. The darkest value can be produced by using the softest graphite pencil. If you wish, you can add each of these pencils to your artist's toolbox, but a good value range also can be obtained by using a 2HB and a 6B pencil. The 2HB pencil is close to our everyday

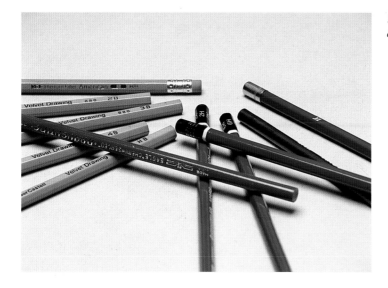

1. *There is a wide range of pencils available.*

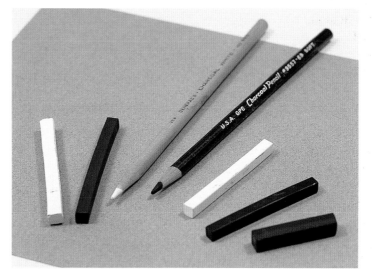

2. *The value range of the 2HB (medium soft) pencil is shown on the left side and the value range of the 6B pencil (very soft) is shown on the right. In the center, the basic #2 pencil.*

#2 pencil in hardness. Adjusting your hand pressure on the pencil during the rendering or shading process will affect the darkness and lightness of the line. Experiment and see which ones you enjoy using (Figs. 1 and 2). Soft graphite sticks (6B) are useful for transferring drawings.

Charcoal

Charcoal is probably one of the oldest art materials. Prehistoric man used charcoal to draw on cave walls. Charcoal is an impure form of elemental carbon, made by burning sticks of wood with very little oxygen. Charcoal is fairly easy to use and is stable over time. By compressing and forming the charcoal, various degrees of softness can be achieved (Fig. 3). Charcoal frequently is used as a preliminary sketching tool, following which painting or drawing is done over the charcoal sketch. Recently, people have begun to frame and preserve

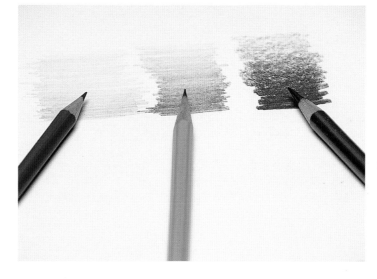

3. *Charcoal tools include black and white pencils, sticks, and conté crayons.*

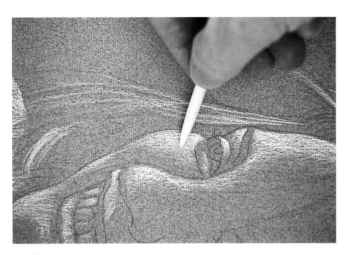

4. *Blending white charcoal with a stump.*

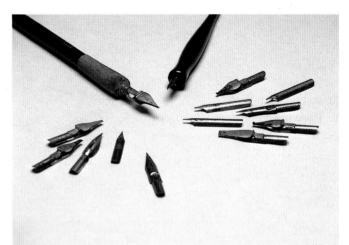

5. *Dip pens: nib holders and nibs.*

charcoal drawings. Spraying with fixative is essential to preserving charcoal drawings. A blending stump (tortillon) is used for charcoal and pencil (Fig. 4).

Colored Pencils and Chalks

There is a wide variety of other drawing implements, including colored pencils, chalks, and oil pastels. Each has its own characteristics. Get to know what they can do, so you can expand your drawing vocabulary. In Project 7 we'll be working with colored pencils.

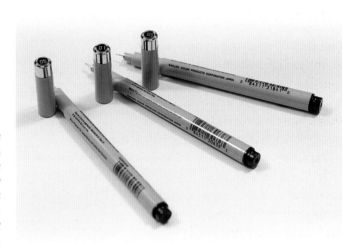

6. *These three drawing pens with ink reservoirs, sizes 05, 01, and 005, were used for the ink drawing in this book. They give very consistent lines.*

Pen and Ink

From dip pens to markers to technical drawing pens, there is a wide variety of pens available. Each has its own personality. Pens offer a great range of expressive possibilities. However, unlike pencil drawing, in which unwanted marks and smudges are easy to erase, drawing in ink is very permanent and is almost impossible to erase. The following tips will help you to prevent unwanted marks and smudges:

1. If you are right-handed, start working on the left side of the paper so you won't hold your hand over the wet areas as you draw. Another method is to constantly turn the paper around to avoid smudging wet ink.

2. Keep the ink strokes short, and start in a dark area of the work.

3. Place a small piece of paper under your drawing hand.

4. Each pen stroke is important to the effect of the immediate area being worked, so control the quality of each stroke.

5. Get an electric eraser and insert a white grit eraser in it, and use an erasing shield. They can make miraculous saves.

6. Stop working when you are tired.

Pen Types

There are dip pens (Fig. 5) and pens with self-contained ink reservoirs (Fig. 6), and many kinds of markers available. Inks come in black and in colors. Some are waterproof when dry.

Speedball produces a line of various dip pen points. Their C-6 nib will produce a fine line for drawing. Even finer lines can be made from a crowquill pen. Some drawbacks of these two pen types:
1. They must constantly be dipped in an ink bottle or other reservoir.
2. They must be wiped properly on the ink bottle, to avoid spillage.
3. Especially with the crowquill, the nib can catch on the fibers of the paper and spill or puddle ink.

The Rapidograph pen has been used successfully for decades. Rapidographs come in a wide range of thicknesses and give a very consistent line. The ink is self-contained in an ink cartridge. A pen needs to be purchased for each of the different widths, and proper cleaning procedures need to be maintained or the pen will cease to work.

Today, there is a wide assortment of inexpensive self-contained ink pens under various brand names. I suggest you find one of them. Rollerball and fiber-tipped pens come in many nib sizes. The most useful are 005, 01, and 05 (Fig. 7). The 05 is rather thick, but it can be used to work areas that you want to be mostly dark. Working with wide-tipped pens reduces the finesse and subtlety of the drawing. When the width is too large, you see the individual line. This may not be desirable if you want a series of small marks that work together to form a pattern, value, or gradation of tone.

7. Ink drawing with cross-hatch shading; by Bob Capitolo.

Papers and Other Surfaces

A visit to your local art supply store will allow you to see and feel the range of boards and papers available. Bristol board, coquille board, and eggshell mat board, as well as pastel paper, offer good textured surfaces for drawing. A pad of 18″ × 24″ (46 × 61 cm) newsprint is invaluable for sketching and preliminary work. Drawings on newsprint are meant to be temporary, because the surface will oxidize and yellow in a short period of time. For drawings that you want to last, use acid-free paper. You probably will find there is a wide variety of other papers and boards available, ranging from kraft paper to oak tag folders.

To get sharp, crisp lines, hard, smooth surfaces are recommended. Hot-pressed illustration boards and papers will work the best; however, some cold-pressed boards will work almost as well. The hot-pressed process is not ideal if you wish to mix media, for example using ink and watercolor in the same artwork. The paint will not be absorbed into the board. It will collect on the surface and sometimes will change value as it dries. If you want to mix media, use cold-pressed boards or papers, which will absorb the paint. Try several surfaces to see which ones you prefer. Be sure to test a cold-pressed illustration board with a 100% rag paper surface. Art supply stores have a number of heavyweight boards.

Erasers

Only two types of eraser are essential. The first is a kneaded rubber eraser, which can be shaped and reshaped. It can be formed to a large flat shape, a point, or a chisel edge. It is cleaned by stretching and pulling to expose the clean part, thus the word "kneaded." It is not designed to rub or scrub the graphite off a surface, but to be pressed down and lift off the graphite. With practice, you also can use a kneaded rubber eraser in shading, to create gradations of tone. The second important eraser is a white eraser. This eraser has a slightly gritty texture and will not leave a residual color as a pink eraser would (Fig. 8).

One additional useful piece of equipment is an electric eraser, a handheld machine that has saved many artworks from unwanted India ink, watercolor, and heavy pencil marks. Use a low-grit white eraser in the electric eraser. To erase a specific area, use a metal erasing shield to protect the surrounding area and control the erasure (Fig. 9).

Fixative

Fixative is a sprayable solution used to help adhere the particles of graphite, charcoal, pastel, conté crayon, etc. to the paper. A coating of fixative always should be applied to a finished graphite pencil drawing. It also may be sprayed on the drawing at various stages of the drawing's completion. Always use a thin coating. If applying fixative before the drawing is finished, be aware of several things:
1. All stray marks and smudges must be removed before you spray.
2. The spray may affect the texture of the paper in the area that is not yet shaded. This area can be blocked out with a piece of paper, preventing overspraying. On a scrap paper, practice both the block-out and shading on top of a sprayed area to become aware of the difference.

Use a mat (nonshiny) finish fixative in a pressurized can. There are environmentally friendly brands available. Keep the artwork upright to avoid dripping spray onto the surface of the drawing, which occurs if there is a buildup of liquid on the nozzle of the can. Spray in a circular motion, about 14″ (36 cm) from the surface of the drawing. A thin coat is best, followed by a second application. Spray outdoors, if possible, or in a well-ventilated room, and avoid getting the spray in your eyes.

9. Supplies include an electric eraser, graphite stick, and an eraser shield (at right).

8. A white eraser and a kneaded rubber eraser were used extensively for the drawing techniques shown in this book.

Scratchboard

Scratchboard was invented around 1864 by Karl Angerer and was first used in Philadelphia by Charles Ross in 1880. As early as the 1900s, illustrations for newspapers and magazines were created in scratchboard. It resembled wood engraving but was much easier to do. Today, scratchboard has developed into an art form of its own.

Unlike the paper and boards used for pencil drawing and ink drawing, which are light surfaces on which you make dark marks, a scratchboard's surface is black. It has a coating of chalk or gesso, covered by black ink. The coating is cut away with special tools to produce a white-on-black drawing. Art supply stores usually carry a thin board under the name of "budget," "student," or "classroom." These inexpensive boards will work to some degree, but the chalk coating is rather thin. Because the board is thin, the corners may warp or dog-ear, causing the chalk and ink surface to chip and flake off. When you are cross-hatching, portions of uncut black ink may chip off. All of this is undesirable.

See if you can purchase a high-quality board that has a heavy gauge (thickness) and a thick application of chalk. This type of board will allow for corrections and overscratching. There will be less chance of the surface chipping or flaking when cross-hatching. Save all scrap pieces of board for experiments.

There are several types of cutting tool available for scratchboard. One is a diamond-shaped nib, used for cutting fine lines; another is a curved, spade-shaped nib, for removing a large area in one stroke (Fig. 10). The holder for both nibs is basically the same as that used for holding pen nibs for pen-and-ink drawing. These two kinds of nib and the holder are all you really need, but a craft knife, dental tools, fine saw blades (broken), a wire brush, a variety of sandpapers, and coarse steel wool could all be tested for their textural effects. Some scratch tools that produce multiple fine parallel lines also are available. If the scratching tool slides over the board's surface without cutting into it, the cutting blade may be dull. Replace the nib.

Miscellaneous Tools and Supplies

There are several other tools and supplies that you'll need to do some of the activities in this book. You may have many of them on hand already:

■ Tracing paper is useful for transferring a drawing from a rough sketch to the final paper and for planning compositions.
■ Thin cardboard can be used to make viewfinders, which help you to plan compositions.
■ A ruling compass is useful for making circular viewfinders (Fig. 11). We'll be using a compass in Project 7.

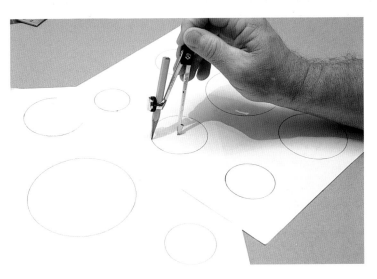

11. A ruling compass and thin cardboard for making circular viewfinders.

10. Scratchboard and tool holder with cutting tool and extra nib.

■ Scissors are needed for making viewfinders and cutting out images used for planning compositions.

■ A craft knife is helpful for cutting circular viewfinders (Fig. 12).

■ An accurate ruler is needed for some methods of enlarging images, making viewfinders, etc. (Fig. 13).

■ For the drawing done on a gessoed board, you'll need some white acrylic gesso and a fan brush (Fig. 14).

■ Images, either your own photos or pictures from magazines, are good sources of material for drawings.

■ Interesting objects to draw. For example, a few shells, a few kitchen tools, cups, teapots, jars, etc.

See the activities for more details.

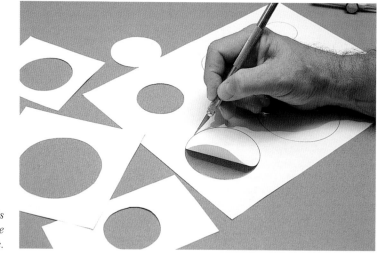

12. A craft knife is used to cut some circular viewfinders.

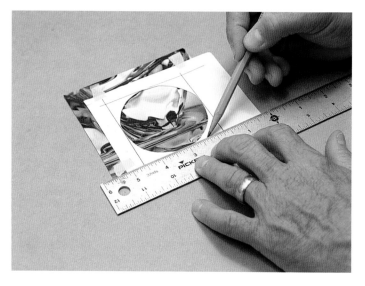

13. Using a ruler for enlarging a circular composition. See Project 7 for details.

14. An old fan brush for applying gesso.

Basic Concepts

Certain basic ideas can give you a starting point for thinking about art. You may find it helpful as you start drawing to learn a little about these and increase your visual vocabulary. If you already are familiar with these concepts, you may want to go directly to the projects section of the book.

Elements of Art

There are certain basic elements or building blocks of art:

LINES: A line is a mark on a surface. It may describe a shape or outline. Lines can create texture and can be thick or thin (Fig. 1).

COLOR: Color is the response of our eyes to a certain wavelength of light that is bounced back to them by a surface. Any color (such as red, blue, light green, pink) has three properties: hue, intensity, and value (light or dark). The color wheel is a way of showing the color spectrum of light turned into a circle, which helps us to study it (Fig. 2). It shows colors made with the primary triad (red, blue, and yellow) when paint is mixed. Complementary pairs of colors are located directly opposite each other on the diameter of the color wheel. Complements can produce dull or neutral colors when mixed (Fig. 3). Shades of a color may be mixed by adding black to the color. Tints of a color may be mixed by adding white (Fig. 4). Tones of a color may be mixed by adding gray. There is more about color in Project 7.

TEXTURE: Texture is the degree of roughness or smoothness of an object. Texture refers to surface quality—either tactile (real differences that you can touch, such as lines cut in a scratchboard) or visual (images of texture that are suggested by drawing, painting, etc.; see Fig. 5).

1. *Graphite lines on gesso. Detail of drawing by Bob Capitolo.*

2. *Color wheel, showing primary colors (red, yellow, blue), secondary colors (orange, green, violet), and tertiary colors (yellow-green, blue-green, blue-violet, red-violet, red-orange, yellow-orange).*

3. *Complementary colors, when combined in certain proportions, make a dull or neutral color, shown at right.*

4. *Tints and shades of blue and orange. At top: value scale from light to dark.*

SHAPES: Shapes are two-dimensional outlines of things. Shapes are flat and include geometric and organic shapes (Fig. 6). Geometric shapes are made with straightedges and ruling compasses; organic shapes are looser and look more like living things.

FORMS: Three-dimensional forms have volume and thickness as well as length and width (Fig. 7a). The illusion of a three-dimensional effect can be created with light and shading techniques (Fig. 7b).

VALUE: Value is the degree of light or dark in a drawing. Colors have value as well, and we can create tints, shades, and tones of a color. Using contrast between light areas and dark areas and providing a variety of shades and tones are ways to use value as a design element (Fig. 8). Values help to create the feeling of three-dimensionality.

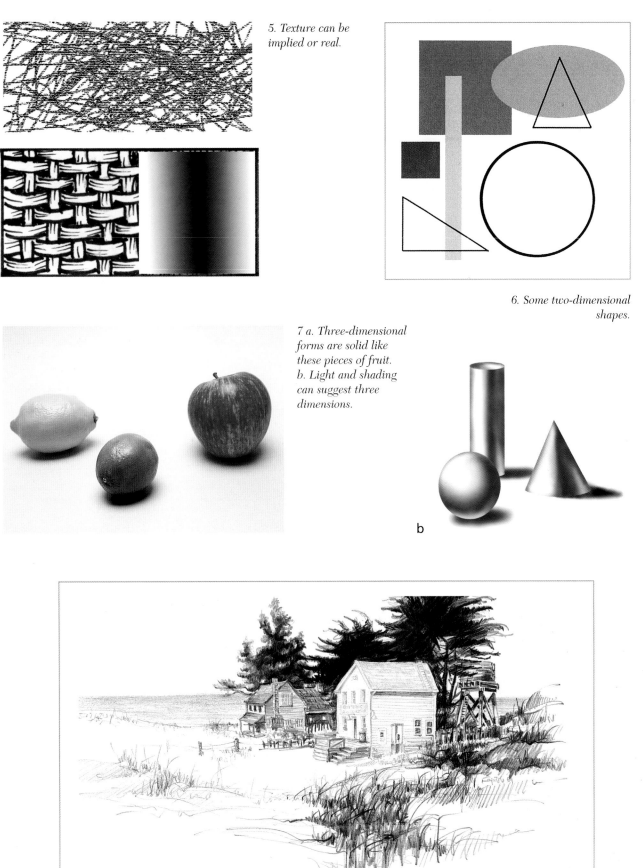

5. *Texture can be implied or real.*

6. *Some two-dimensional shapes.*

7 a. *Three-dimensional forms are solid like these pieces of fruit.*
b. *Light and shading can suggest three dimensions.*

a

b

8. *Contrast of light and dark is seen in this drawing by Bob Capitolo.*

SIZE: A variety of sizes of objects, lines, and shapes creates interest and avoids monotony.

SPACE: Space, in an artwork, may be occupied by the forms or objects and by the areas between the forms or objects. Space can be represented as flat or as three-dimensional. In a representational artwork, there is positive and negative space. The space in and around the forms and objects in an artwork is the negative space. The forms and objects themselves in an artwork are the positive space (Fig. 9).

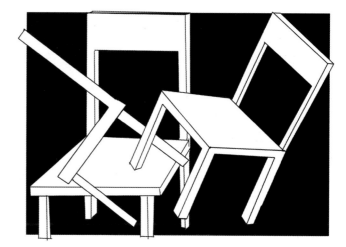

9. *The chairs are the positive space and the black is the negative space.*

QUALITIES OF SHADING

Shading is the gradation of tone, or the merging of one shade or value into another. There are five aspects of shading that help to create a three-dimensional illusion in a drawing:

LIGHT SIDE/DARK SIDE: The light and dark areas establish the direction of the light source. There is an implied line where the shaded and light side meet. Gradual change of values is seen on rounded forms.

HIGHLIGHT: A highlight is a small, intense reflection of light found on the object where the light hits it directly. The highlight usually is in a shape that corresponds to the form of the object. It is the area of lightest value on that object.

CAST SHADOW: The cast shadow is produced when the object casts a shadow because that object is

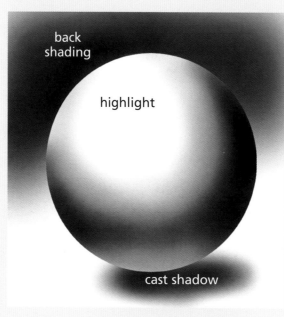

S-1. This sphere has all of the qualities of shading needed to suggest a form: highlight, light and dark sides, shadow, reflected light, and back shading (shading in the background).

blocking the light's passage. The edge of the shadow is darker at the base of the form and fades out from there. The cast shadow can give information about the direction of the light source; it attaches the object to the ground or other surface on which it rests.

REFLECTED LIGHT: Reflected light is on the dark side of the object or form. It comes from light bouncing off surrounding objects or from a surface. Reflected light is not as bright as a highlight. It helps to show volume in the shaded areas.

BACK SHADING: Back shading is the area that is shaded behind the form. Back shading reveals the back-shaded object's edge. In general, a lighter area seems to move towards you and a darker area usually recedes in a drawing.

10. *In this composition by Ken Schwab, the center of interest has many changes of shape and value near each other.*

Principles of Composition

A composition is an orderly arrangement using the principles of design. The principles of design help you to carefully plan and organize the elements of art so that you will hold interest and command attention. This is sometimes referred to as visual impact.

 A well-designed work has pleasing rhythm and movement. The center of interest is strong. Viewers will not look away; instead, they will be drawn into the work. A good knowledge of composition is essential in producing good artwork. The principles that follow will help you use the elements of art to create a good composition.

CENTER OF INTEREST: The center of interest is an area that first attracts the viewer's attention in a composition (Fig. 10). It is the most important area, compared to the other parts of a composition. The emphasis can be achieved by contrast of

11. *The naturally occurring four aesthetic centers of interest at the intersections, located by using the division of thirds.*

values, colors, shapes, sizes, textures, etc., and by placement of things on the paper.

 The division of a visual field in thirds can help you to find a good place to put the aesthetic center of interest of your artwork. The word "aesthetic" refers to beauty in art and to making a pleasing arrangement of the elements into a harmonious composition. Over the years,

people have discovered that certain areas in a visual field naturally have attracting power and are good places for positioning the center of interest. If you divide the visual field horizontally into three equal parts and vertically into three equal parts, the lines drawn intersect at four different points (Fig. 11). These points are good places to locate the center of interest.

BALANCE: Balance is a feeling of visual equality in a composition with regard to shapes, forms, values, colors, etc. Balance can be symmetrical (formal) as in Figure 12 or asymmetrical (informal) as in Figure 13. Each object in a visual field has its own attracting power for the eye, in part based on where it is in relation to the other objects.

HARMONY: Harmony means using shapes or things that go together and are similar in some way, so no shape or object feels out of place in the work (Fig. 14). Harmony brings a composition together by the use of similar units, objects, etc. If your composition has wavy lines and organic shapes, for example, you would use those types of line and not suddenly put in one geometric shape.

Harmony is the use of shapes or things that unify the composition so no shapes or objects feel out of place.

CONTRAST: Contrast refers to variation in values, textures, shapes, size, etc., in a composition. Contrast in shades and gradations between objects and

their background can bring objects forward in a design. Contrast also can be used to help create an area of emphasis. When choosing subject matter, look for contrast as well as harmony.

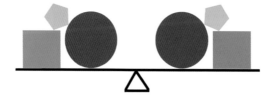

12. Symmetrical balance: equal objects on both sides of the composition are at the same distance from the center.

13. Asymmetrical balance; unequal shapes are on either side, but they balance each other visually.

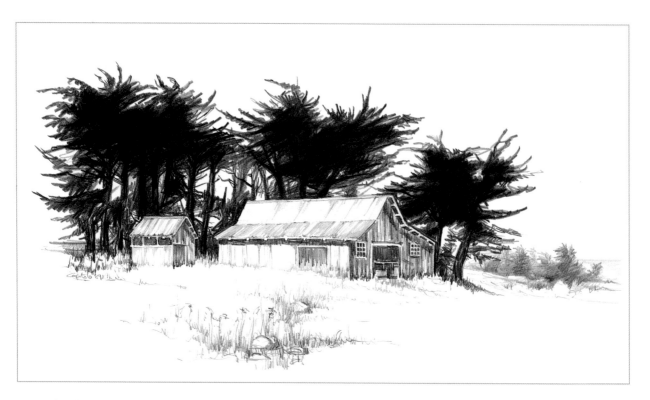

14. In this drawing by Robert Capitolo, the shapes of the house and cabin are in harmony and the trees and structures all work together in a harmonious way.

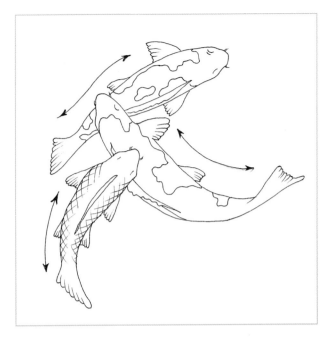

15. Directional movement perceived as a result of the positions of the fish.

16. Shapes and changes in value create directional movement.

17. The strong brushstrokes and recurring shapes in this painting by Bob Capitolo set up a rhythm.

DIRECTIONAL MOVEMENT: Directional movement is a visual flow through the composition. It is the path your eye travels as it looks at the artwork. There can be the suggestion of motion in a design as you move from object to object because of their placement and position (Fig. 15). Directional movement can be created by overlapping shapes or by value patterns. The placement of dark and light areas can move the viewer's attention through the work (Fig. 16).

RHYTHM: Rhythm refers to visual movement in which some design elements recur regularly. The placement, color, size, and shape of objects as well as the repetition of line and the values in an artwork create a visual flow, something like the beat in music (Fig. 17).

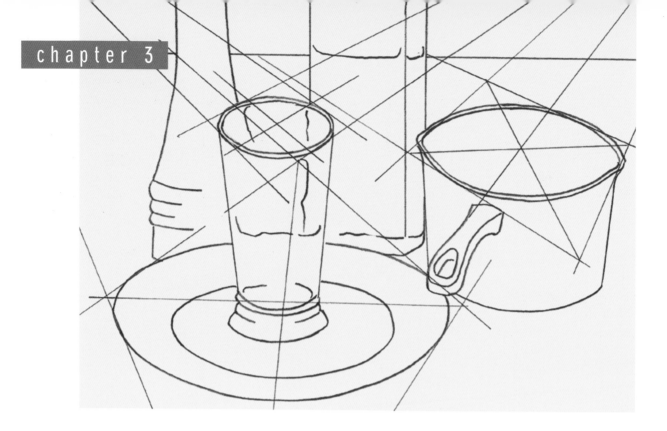

Sketching and Suggesting Depth

Drawing is basic to art. In essence, drawing is the process of making marks, using a medium such as charcoal, pencil, or pen, that will adhere to a surface. The artist makes a series of these marks or lines to develop a rendering or interpretation of what he or she has seen. A basic concept of drawing is to force yourself to see and not just look at the subject matter. Seeing implies close observation.

To move from a contour drawing to a suggestion of depth in a drawing requires shading. When lines are drawn closely together, they create values or tones of gray. This is the essence of the shading process (Fig. 1). Various shading techniques are discussed and illustrated in examples later in this book.

Rough Sketches

A sketch of a subject could be an end in itself, but usually it is a preliminary stage for a more refined drawing. A sketch is composed of a series of loose, free, rapidly applied lines that represent the essence of the subject matter

(Fig. 2). Expressive overlapping and lightly rendered lines also can be used.

Rough sketches and thumbnail sketches are almost synonymous. They are usually small, as in the case of the thumbnail sketch, devoid of details, and are quickly rendered. They represent possible compositional arrangements. When two or three of these preliminary drawings are compared and critiqued, they help in the developmental and planning stage of the final composition (Fig. 3). Instead of using rough sketches or thumbnail sketches, some people draw spontaneously on paper. With practice and experience, you may find this

approach more to your liking. However, when you are a novice at drawing, a little more planning and preparation may help you to create a good composition. For this reason, we suggest that you draw and critique at least two thumbnail sketches before starting a final drawing.

Drawing from Photos and from Observation

There is one question that people always ask: "Is it alright to draw from a photograph?" A quick answer is: "Yes." A carefully selected photograph can put you in immediate visual contact with your subject matter. Even if you drew the same view from observation as the one you saw in a photograph, you would not create a mere copy. Whether drawing from nature or from a photograph, your creative processes enable you to do such things as organize, simplify, and emphasize the subject matter.

Drawing from observation, using actual subject matter rather than a photo, allows you to change the composition of your subject matter freely. For example, with a still-life drawing, having the actual objects there lets you pick up the subject matter and see it more closely, look at it from different angles, reposition it in a grouping, etc.

1. A gradation of closely spaced lines creates a value change from a light gray to darker tones.

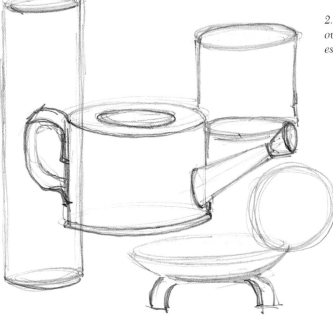

2. When sketching, use loose, overlapping lines to express the essence of the object.

3. A series of thumbnail sketches to try out various compositional arrangements.

21

More About Forms and Shapes

A shape is the external surface or outline of a specific form. The drawing of a shape is two-dimensional, having length and width. It is usually seen as an outline drawing. Shapes are flat. They have no volume or thickness, and may be represented by an outline. A shape also can be represented by a solid, filled-in area or by a series of lines closely placed together, which imply a shape. A shape can be geometric, such as a square or circle, with angles and straight-edged outlines, or organic, with soft, flowing, curved outlines.

A three-dimensional form may be represented on a two-dimensional surface by a drawing showing the volume of an object or person—its length, width, and depth. There are six basic geometric forms: cube, sphere, cone, cylinder, pyramid, and prism (Figs. 4a and 4b). These forms are at the core of the objects that we encounter every day, such as a ball, a box, a can, a drinking glass, or a simple roof. The human body also can be thought of as a combination of geometric forms.

Geometric forms have related or counter shapes (Fig. 5). Some have more than one related shape, depending on the angle at which you look at the object. For example, the bottom of a cone is a circle. Seen from the side, a cone has a triangular shape.

FORM	RELATED SHAPES
1. cube	1. square
2. sphere	2. circle
3. cone	3. triangle and circle
4. cylinder	4. rectangle and circle
5. pyramid	5. triangle and square
6. prism	6. triangle and rectangle

Complex Forms

Most forms that we encounter in our daily lives are complex forms. When drawing these complex forms, see if they are a combination of basic forms that are connected by geometric or organic lines; this will help you in drawing them.

When drawing animals or people, begin with basic circles, ovals, cones, and cylinders. When drawing still-life

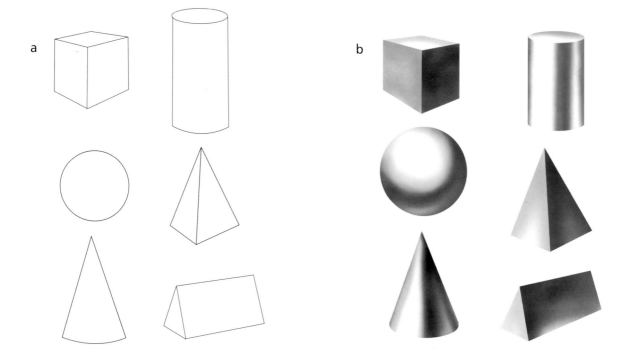

4 a. Linear drawings establish the structure of three-dimensional forms. b. Shading reinforces their volume.

objects, start with those basic forms that are intrinsic to the complex form. For the technique of building up basic forms to create a complex form, it is advisable to sketch your lines lightly. If your subject matter is a flower vase with a round base and tapering sides, you might approach the drawing as follows:

1. Start with the round part of the vase by drawing a sphere. Imagine that you are locking your wrist and move your arm in a circular manner, so you draw with your whole arm. Several overlapping circular shapes will develop. Do no erasing at this stage, unless there is an obvious size error.

2. When you connect the upper cylinder to the sphere, draw this new form in the same light manner, using several sketched lines (Fig. 6). This stage of the drawing should be light, loose, and free, representing the core of the subject matter. If you are seeing the vase from a side angle rather than directly overhead, the top and base will look like ellipses, instead of circles. This is the effect of perspective.

3. You will need to add connecting lines from one basic form or area to another and perhaps you will need to correct the proportions. When you are through drawing the combination of overlapping basic forms and making corrections (Fig. 7), go back over the sketch and refine the multitude of lines into one clean outline of the subject matter.

5. Geometric solids and their counter shapes.

6. A cone with its top removed is added to the sphere to create the middle section of the vase form.

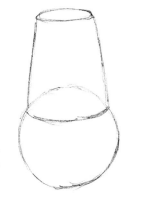

7. As more basic forms are added to the drawing, the complex structure emerges.

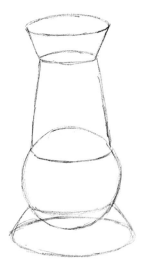

8 and 9. Two examples of atmospheric perspective.

Using Perspective and Other Ways of Suggesting Depth

If you are working to convey a representation of actual objects, you probably will want some way of conveying the interrelationship of the objects in three-dimensional space. Perspective is a system of representing three-dimensional objects on a two-dimensional surface so that the effect is the same as if the actual scene or object were viewed from a given point. There are various cues that help the viewer understand the depth in your drawing. The formal understanding of the mathematical rules of linear perspective wasn't achieved until the Italian Renaissance. We can use some simple concepts from linear perspective to help us. Below are some helpful things to keep in mind for suggesting depth.

Atmospheric Perspective

Atmospheric perspective is in effect when there is a value change from dark, saturated (intense) foreground colors to light, pale background colors (Figs. 8 and 9). The effect of atmospheric perspective can be easily seen if you look out on a long view of the foggy countryside. The trees, rocks, bushes, etc. that are nearest to you will appear dark and sharp-edged. In addition, as things in the landscape are farther and farther away from you, the edges of the subject matter become more and more blurred. The vegetation

becomes a middle tone of gray, and eventually the distant landscape will appear in an extremely light value. Finally the landscape disappears into the clear haze of the sky. You can achieve a similar effect in a drawing. For guidance, establish a value scale on a separate sheet of paper. With pencil, you can create a value scale with a seven-step value range, starting with black at one end and becoming progressively lighter in tones of gray until it ends in white at the opposite end of the scale. Use the darkest values for those objects closest to you and make the objects

10. *Diminishing clarity. Boats and waves nearby are much clearer than those far away.*

11. *An example of interposition.*

farther away lighter in value. The farther away they are, the lighter the value. The same value changes can be done in a color drawing.

Diminishing Clarity

Diminishing clarity is a perspective effect that is related to atmospheric perspective. The farther away objects are in the background, the more blurred the subject matter becomes. Diminishing clarity means there is a loss of detail as the subject matter recedes in the distance. The farthest things are completely blurred. The appearance of diminished clarity can be created in a line drawing. Thick or thin lines or pressure-weighted lines can be used to create a fading off and a feeling of depth in the composition. The subject matter in the foreground may be drawn with thick, dark lines; as the subject matter recedes from the viewer, the drawing lines become increasingly lighter and thinner (Fig. 10).

Interposition

When the outline of one shape or form interrupts another shape, we usually assume the interrupted shape is behind the other shape or form. This depth cue is called interposition. We see this in Fig. 11, where the dark arched window cuts into the shape of the church courtyard, so we know it's closer.

Size and Spacing

Things in the distance look smaller than things nearby. Trees that may be very tall look like matchsticks when they are in the distance. Things that are far apart—for example, fenceposts—look close together in the distance. You can see this effect in Fig. 10, where the distant boats look very tiny.

Linear Perspective

Linear perspective can be a big help to an artist trying to portray objects in space. It's helpful for buildings in landscapes as well as for still lifes.

One-Point Perspective

In one-point perspective, the front of the subject is parallel to the picture plane (Fig. 12). All parallel lines on the subject that are not parallel to the picture plane converge at the same vanishing point (VP) on the horizon line. Railroad tracks are the classic example of one-point perspective (Fig. 13). Figure 14 is another example of one-point perspective.

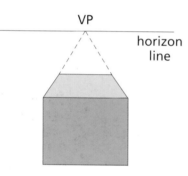

12. A box, seen in one-point perspective.

Two-Point Perspective

In two-point perspective, the main subject is at an angle to the picture plane (Fig. 15). Parallel lines on the sides of the subject converge at two vanishing points on the horizon line. If the vanishing points are too close together, a keystone effect will show up in the drawing, distorting the subject. The drawing will have a more realistic appearance if the vanishing points are far apart. When you are trying to locate your vanishing points, an extra strip of paper sometimes needs to be added on both sides of the drawing paper, and you may need to extend the horizon line off the paper. Then determine your vanishing points and remove the extension papers.

14. Another example of one-point perspective.

Most realistic still-life drawings are rendered in two-point perspective. They are sketched and drawn without much consideration to using a horizon line, vanishing points, or converging lines, because those concepts already have become a natural way of drawing for their creators. This is fine after a certain amount of "artistic mileage" is behind you. In the beginning, using the vanishing points, horizon lines, etc. is a good technique to follow until you feel comfortable with your drawing skills.

Three-Point Perspective

Adding a third vanishing point to the drawing creates a more dramatic appearance to the composition. This is necessary when you are way above or way below the subject matter. You

13. Railroad tracks converge in the distance; an example of one-point perspective.

can look up at tall buildings if you have a low horizon line or look down on buildings if you have a high horizon line (Fig. 16). In either case, the third vanishing point is best positioned close to the vertical center of the format. The third vanishing point probably needs to be positioned off your paper, which you can do by using paper extensions, as was mentioned in the discussion of two-point perspective.

Foreshortening

Foreshortening occurs because the near part of an object that is close to you appears larger than the part farther away. Imagine a person walking up a hill in front of you (Fig. 17). His near foot and leg appear much larger than his far foot and leg, because of perspective.

Almost any subject matter could be used when creating a drawing to show the principles of foreshortening. The main concept is the positioning of the subject matter in relation to the viewer. Always locate one end of the subject matter closer to you and the other end going off into the background. Try taking a photo of someone holding a hand in front and a hand behind him, or look at a rolled-up newspaper with its end towards you for examples.

17. Foreshortening can be seen here; the near leg and foot appear much closer than the far one.

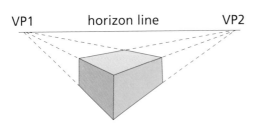

15. In two-point or angular perspective, lines extended from the box sides to the vanishing points converge on the horizon line.

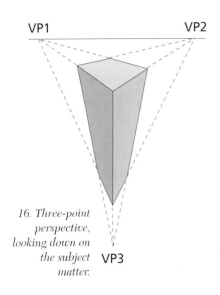

16. Three-point perspective, looking down on the subject matter.

VOCABULARY FOR LINEAR PERSPECTIVE

HORIZON LINE: a horizontal line at the viewer's eye level, at the farthest distance visible. In a landscape it may be where the sky meets the land or ocean. When the viewer's eye level changes, the horizon line changes also.

EYE LEVEL: what you see depends very much on the relation of your eye level to the subject.

STATION POINT: the place from which the viewer sees the subject.

PICTURE PLANE: an imaginary plane between the viewer and the subject, perpendicular to the line of sight.

LINE OF SIGHT: a straight line from the station point to the subject, perpendicular to the picture plane.

VANISHING POINT: a specific point on the horizon line where lines that are actually parallel in real life seem to meet. In one-point perspective, there is one vanishing point; in two-point perspective there are two vanishing points, and in three-point perspective, there are three vanishing points, but the third point is not on the horizon line.

PARALLEL LINES: two or more lines that are an equal distance apart.

CONVERGING LINES: two or more lines that come together at a specific point.

FORESHORTENING: a perspective effect that occurs when an object is placed directly in front of the viewer. The near part of the object seems wider and larger than the faraway parts of the object.

Arrange and Sketch a Simple Still Life

When drawing a still life, look for the basic geometric forms that are the main structure of the more complex forms; check the drawing for possible corrections using your knowledge of perspective.

materials

4 to 6 related kitchen items
drinking glass
18" × 24" (46 × 61 cm) newsprint
pencil, 2H
eraser
still-life arrangement

1 Choose objects that vary in height, size, and shape, as they do in Figure 18.

2 Set up a vertical still life in which the width of the format is narrow and there are tall objects or a horizontal still life with the objects relatively short and spread out. Arrange the paper to go with your setup.

3 If you aren't sure of the horizon line, with a drinking glass you can establish where the horizon line is. The horizon line is always at your eye level (Fig. 19).

4 You will not be able to see the tops of objects that extend above the horizon line (your eye level) unless the objects are transparent. The tops of objects that end on the horizon line also will not be seen; they will appear flat. You will see the tops of the objects if they end below the horizon line. Notice which objects end above, on, and below the horizon line.

5 Look for the basic geometric forms that are within the complex forms (Fig. 20).

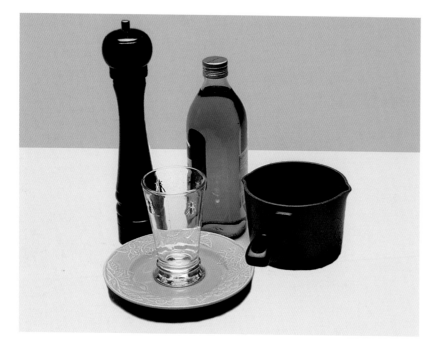

18. Use a group of related items with a variety of sizes, shapes, values, textures, and colors.

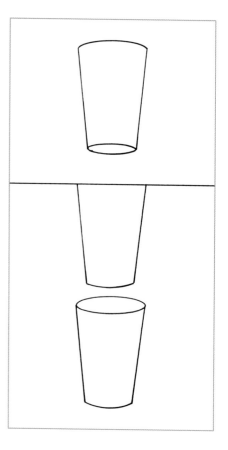

19. A drinking glass, raised or lowered, will show where the eye level line (horizon line) is located in the still life, when the top of the glass is completely flat.

6 Start to sketch the still life on the newsprint. Working large can create a little more freedom when rendering the objects.

7 Try to figure out where the vanishing points of your objects would be (Fig. 21). Use two-point perspective lines to correct sides, tops, etc., as needed.

8 Refine the preliminary sketch to one clean outline for each object (Fig. 22).

9 Use your sketch as the basis of a finished drawing, if you like.

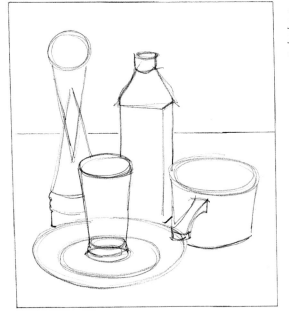

20. Discover the basic geometric forms that comprise the complex forms, and start to sketch the basic forms.

21. Once the horizon line is established, if accuracy of the sketch is the intention, set up the vanishing points and construct converging lines to see if the objects are drawn correctly.

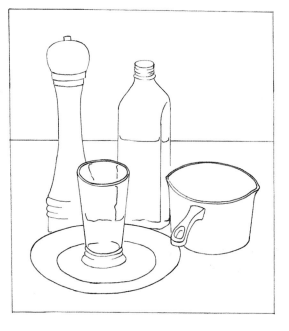

22. Simplify the sketch and get rid of the perspective lines.

29

Working with Images: Cropping and Grids

This chapter will help you perfect your composition skills and explore some possibilities for enlarging and distorting subject matter by using grids. To create a good composition, you need to consider the basic principles of composition: having a center of interest, directional movement within the subject matter, balance, harmony, rhythm, and contrast. These are all covered in detail in the chapter on basic concepts.

The principles of composition are not absolute rules. Rather, they are open-ended guides that allow you to go through a creative problem-solving process. With practice, creating a good composition becomes instinctive. This chapter deals with some tools to use as aids to composition, which will be of particular help to a beginner, although many experienced artists use them as well.

Using a Viewfinder to Help Choose a Composition

A viewfinder is a frame with a window, which lets you select a portion of a much larger visual field. The viewfinder can be a circle, oval, square, rectangle, or any other shape you want. There are two basic ways to make a viewfinder.

materials

cardboard
scissors
pencil
ruler
photos
ruling compass

1 Make two "L" shapes from a heavy-gauge paper or light cardboard. Overlap the two shapes and adjust them to form a window (Fig. 1). Hold the viewfinder in front of you and look at a landscape or a still life (Fig. 2). What you see will change when you move the viewfinder closer or farther away from your eye, left or right, or up or down. Experiment until you find a composition you like. The same rectangular viewfinder could be placed over a photograph or large artwork. Adjusting the window opening lets you crop the resource photo to create a new composition. After you make a rectangular viewfinder, do not become stuck with it in a constantly horizontal direction. Check the subject matter for its vertical potential.

2 The second basic way to make viewfinders is to cut round or oval windows (or any other shape you want) in a variety of sizes from heavy-gauge paper (Fig. 3). This will assist you in choosing compositions in oval or circular formats. The viewfinder is then placed in front of you (if you are looking at an actual object) or over the resource image, and moved around to locate the desired composition, which can then be enlarged (Fig. 4). See Project 7 for enlarging a circle.

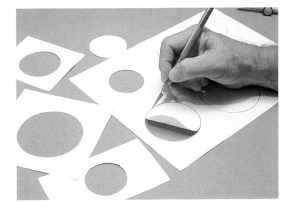

3. Making circular viewfinders.

1. Make a viewfinder of two "L"-shaped forms that can be adjusted to any rectangular format.

2. Using the viewfinder to view a distant landscape.

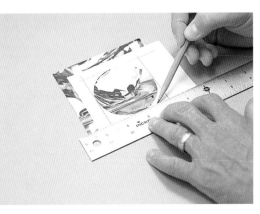

4. A composition, once chosen, can be enlarged.

31

Enlarging an Image by the Diagonal Method

At some point you will need to know how to enlarge an image. For example, you might need to enlarge the photograph you see through a viewfinder. This requires a proportional enlargement of the photo to the size you want. There is one simple method that does not require many measurements—the diagonal method.

materials

photo or other image that is going to be enlarged (resource photo)

newsprint paper large enough to accommodate the enlarged drawing

pencil, 2HB

straightedge, heavy-gauge cardboard, or ruler

T-square or right triangle

rectangular viewfinder, either a cutout window or two "L" shapes

1 Start with a large piece of paper and the viewfinder with the resource photo positioned behind it. Tape the viewfinder onto the photo itself, so you won't have to search to reposition it later. If you use "L" shapes, tape the two L's of the viewfinder together to keep them from moving. Remove the photo and trace the viewfinder window onto the lower left corner of the large paper (Fig. 5).

2 On the rectangle that was just traced, draw a diagonal line from the lower left corner to the upper right corner. Continue drawing the same diagonal line past the upper right corner of the window across the large paper (Fig. 6).

3 Determine how large you want to make your final drawing. To do this, start at the lower left corner of the large paper (where the window is located) and move from left to right along the bottom to the sheet of paper. However long you want the bottom of your final drawing to be, merely make a pencil mark at that desired distance. From that mark, draw a perpendicular, vertical line until it crosses the diagonal line (Fig. 7). At the point where the vertical line intersects the diagonal line, draw a horizontal line to the left side

5. At left, viewfinder. Trace or draw the exact window opening from the viewfinder in the lower left corner of the large sheet of paper.

6. Draw a diagonal line through the small rectangle, extending it across the large sheet of paper, until it hits the top line. This may not be at the corner of the paper.

7. Draw a vertical line from the dot up until it intersects the diagonal line.

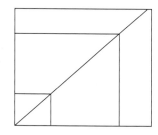

8. Draw a horizontal line from where you just ended in the last diagram to the left side of the paper.

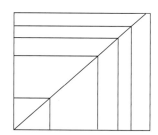

9. You can enlarge the original image to a variety of sizes by repeating this procedure.

of the large sheet of paper (Fig. 8). Be sure the horizontal line is truly perpendicular to the vertical line.

4 This process will always proportionally enlarge the original window, no matter where you make your vertical line (Fig. 9).

To make a drawing that is smaller than your resource image, extend your diagonal line into the window you traced on your paper and draw your vertical and horizontal lines in the same way as for enlargement.

VOCABULARY

FORMAT: the shape of the surface of your artwork.

VIEWFINDER: a paper or cardboard device for visually framing a potential view or image, to aid in choosing and creating a composition.

GRID: a series of crosshair lines placed over a resource image to aid in enlarging or altering the image.

RESOURCE IMAGE: visual material you use as a source for your drawing. It could be a still life, a person, a photograph, a landscape, or a magazine photo, for example.

CROPPING: the cutting away or eliminating of certain areas of a resource image.

NONOBJECTIVE DESIGN: a design that is not based on any subject matter; nonrepresentational design.

activity 3

Using a Grid to Enlarge an Image

materials

rectangular viewfinder
resource photo or other image
2 pieces of newsprint paper for
 enlarged drawing
good drawing paper, the same size
 as the newsprint
pencil, 2HB
soft graphite stick for enlarging
ruler
right triangle or T-square
tracing paper (optional)

A grid overlapping the resource image will help you to isolate a specific area that you want to use and will enable you to proportionately enlarge the subject matter. There are two ways to form the grid on the resource photo. You could use the folding method described below; however, you will end up with a folded enlargement, which you'll need to trace onto your final drawing paper if you use this method. You could use a ruler to measure the sides of your image and create lines forming the grid at regular intervals. To prepare for either method, place the viewfinder window over the resource image until you find a composition you like.

Folding Method of Enlarging

1 Fold the viewfinder in half and in half again horizontally. This will divide the window opening in quarters vertically. Fold the viewfinder in quarters vertically. This will create horizontal lines. Press hard on all the fold lines. If the lines aren't sharp, draw over them with a pencil to form a lined grid. Using the ruler, extend the lines over your photo to divide it in quarters. If you don't want to make marks on your photo, cover it with tracing paper first.

2 Take the newsprint paper on which you want to make your enlargement. Draw the enlarged box on it, with proportions the same as the resource image in the viewfinder, by the diagonal method (see Activity 2). Cut out the enlarged box from the newsprint paper and fold it in quarters horizontally and vertically.

3 You are now ready to enlarge the composition, one rectangle at a time. Start with bold, large areas and leave out small details. The small details can be drawn later; they look better when drawn spontaneously on the final artwork, anyway.

Drawing an Enlarging Grid by the Measurement Method

1 To use the measurement method for grid enlargement, rule evenly spaced lines horizontally across your resource photo as shown on the photo in Fig. 10. Use tracing paper if you don't want to draw directly on your photo. The lines could be ½″ (1 cm) apart or 1″ (2.5 cm) or more, depending on the size and detail of your original and how large you will make it. If you are enlarging something complicated,

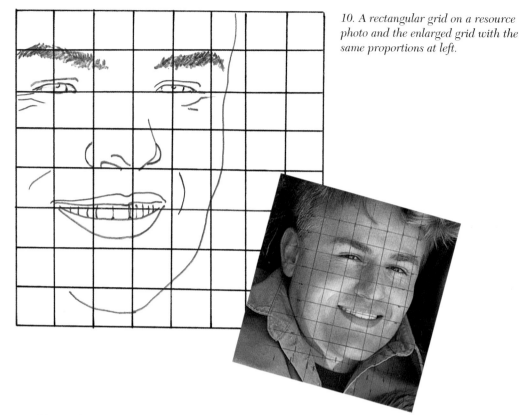

10. A rectangular grid on a resource photo and the enlarged grid with the same proportions at left.

you may want more grid lines than you would for something simple. Then rule evenly spaced lines perpendicular to the horizontal lines on your photo so you end up with a grid of squares.

2 On the newsprint paper for your enlarged drawing, rule horizontal and vertical grid lines that are 2 times wider apart than the width of the resource image in the viewfinder (or more, depending on how big you want your drawing). If each box is 2 times wider, your drawing will be twice as wide and will end up with 4 times the area of the original (see Fig. 10, left).

3 Draw and shade your enlarged drawing the same way as you did for the folding method of enlarging. Then trace the enlarged drawing onto the good paper and proceed to complete your drawing (Fig. 11).

11. The enlarged drawing was traced onto the final paper and completed.

Using a Grid to Distort an Image

materials

viewfinder
resource photo
large newsprint paper
pencil, 2HB
ruler
right triangle or T-square
tracing paper (optional)

1 Draw equally spaced lines in a grid on the resource photo or on a tracing paper overlay, as in Activity 3.

2 On the newsprint paper for the enlargement, you will need to draw grid lines across that are not parallel to each other and draw up-and-down grid lines that aren't perpendicular to the lines across. The key to this process is how the grid on the enlargement sheet of paper is created. The number of lines across and the number of lines up and down must be the same as the number on the resource photo (Fig. 12). This means some squares on the resource photo will be enlarged more than others, because the spaces in the enlarged grid won't all be the same size or shape.

3 For enlarging, it may help to number the corresponding up-and-down lines and lines across, both on the resource image and on the enlarged grid. To enlarge the resource photo, take one corresponding numbered shape at a time and draw its contents as accurately as possible on the same numbered area of the enlarged, distorted grid (Fig. 13).

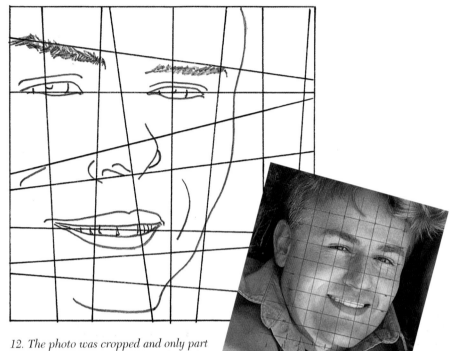

12. The photo was cropped and only part of it was enlarged. Using the grid at left will produce a distorted enlargement.

13. The distorted, enlarged drawing was traced onto the final paper and completed.

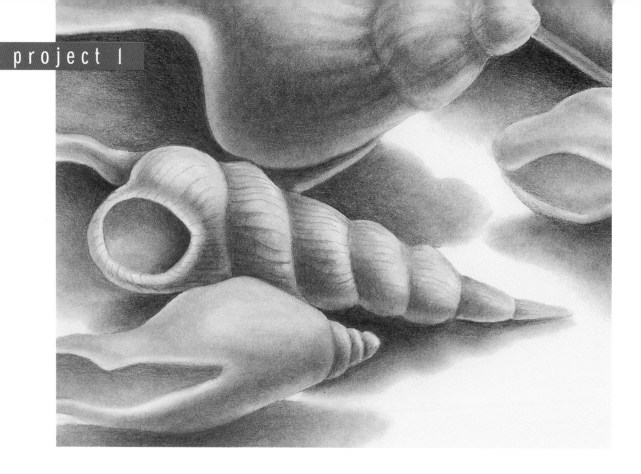

Smudge Shading on a Contour Drawing

This project explains how to draw and shade several related objects, using contour drawing and smudge shading. Since the contour drawing is created from observation, the subject matter needs to be tangible and movable. Assembling similar objects or objects that are found in one setting will provide for a more harmonious composition. Shells of various sizes and shapes were used for the examples that follow. A grouping of kitchen items, old bicycle parts, or children's toys could be used for the composition. Keeping the subject matter simple is a consideration for this project (Fig. 1). If the objects are too complex or detailed, they may complicate the smudge shading technique that is being used.

Contour drawing is a basic drawing technique. This activity shows how to create contour drawings of several related objects.

Creating a Series of Contour Drawings

materials

pencil, 2HB

newsprint (sketching) paper 18" × 24" (46 × 61 cm)

subject matter: about 6 shells, tools, kitchen items, or other related objects

kneaded rubber eraser

1. Use harmonious subject matter for the still life.

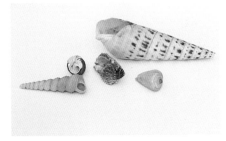

2. Materials for the contour drawing project.

1 In making a contour drawing, imagine that you are creating a continuous line that will reveal the edges of an object. This line not only outlines the object, it also follows the volume and form of the subject matter, creating a drawing that conveys three dimensions (length, width, and depth). It is preferable to make the contour drawing slowly, so you notice all the special things about the object you are drawing.

2 There are two types of contour drawings. One is a "blind" contour drawing. While you are doing the blind contour drawing, keep your eye on the subject matter for the entire time that the pencil is moving on the paper; don't look at your drawing (Fig. 3). When you do a blind contour drawing, the drawing may not look exactly as you wanted it to, but don't be discouraged. It is good practice in looking and seeing.

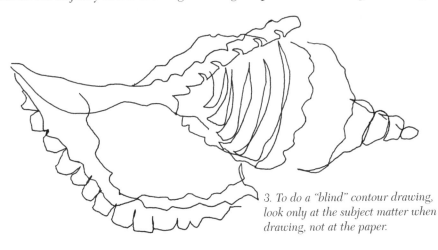

3. To do a "blind" contour drawing, look only at the subject matter when drawing, not at the paper.

VOCABULARY

SMUDGE SHADING: a blending technique using tools to form smoothly shaded gradations of tone.

CONTOUR DRAWING: a line drawing that indicates the volume and form of an object.

OUTLINE: a drawing of the outside edges of an object.

FORMAT: the shape of a surface on which you are working—for example, rectangle, square, circle.

RENDERING: drawing.

STUMP (TORTILLON): a tightly rolled "pencil" made of thin cardboard, used for blending pencil lines or charcoal.

3 The second kind of contour drawing is a "looking" contour drawing (Fig. 4). Look at the subject matter, but occasionally glance at the paper while your pencil is moving. The "looking" contour produces a greater degree of success and satisfaction than the blind contour does. To start, put the pencil on the paper and look closely at the object, concentrating on one point or area of the object. Imagine that the pencil is also touching the object at the same point. As your eyes move slowly around the object, move the pencil in unison with your eyes. Your pencil is drawing what your eyes are observing. Glance down at the paper occasionally to relocate the pencil and to check for accuracy. A perfect drawing is not the goal. Try to avoid erasing.

4 On a sheet of 18″ × 24″ (46 × 61 cm) newsprint paper, draw five contour drawings, following the "looking" contour method. Draw two small contours (7″ or 18 cm wide), two medium contours (10″ or 25 cm wide), and one large contour drawing (12″ or 30 cm wide). Draw on only one side of the paper. The drawings will be cut out later and arranged in a composition. It is not necessary to use all of the drawings in the final composition. Be sure you are satisfied with the drawings; they will be an important resource for the rest of the exercise (Fig. 5).

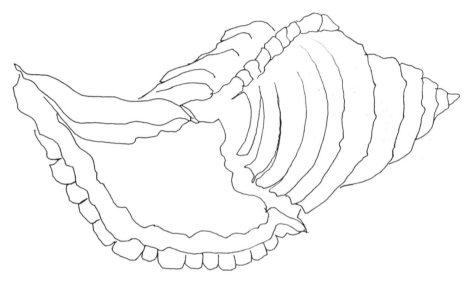

4. To do a "looking" contour drawing, let your eyes sometimes move to the drawing paper from the subject matter, while you are drawing.

a

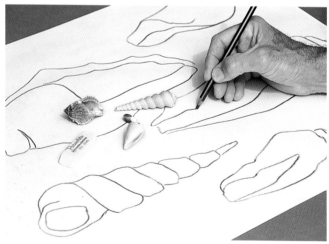

b

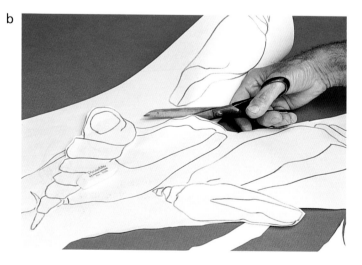

5. a. Five contour drawings Bob did for the project.
b. Cutting out the drawings.

Creating a Composition from Contour Drawings

materials

5 contour drawings (see above)
pencil, 2HB
graphite stick, 6B
white drawing paper, 18″ × 24″
 (46 × 61 cm)
heavyweight newsprint paper,
 18″ × 24″ (46 × 61 cm)
scissors
masking tape
paper towel

1 All five contour drawings you made in Activity 1 are needed for this activity; however, you may not need all of them to complete the composition. Cut around each drawing, leaving a ⅛″ (3 mm) border around each, and set them aside.

2 On a sheet of newsprint, start to arrange contour drawings in a composition. Begin with the object(s) that will go in the center of interest area. Next, imagine the location of a triangle in the work that will assist in the balance and directional movement of the remaining drawings. You don't have to use all of the drawings; avoid a cluttered appearance (Fig. 6). When you are satisfied with the way the drawings look in relation to each other on the paper, use the masking tape to stick the drawings to the newsprint.

3 Turn the newsprint with its drawings over so it is face down. With the 6B graphite stick, rub the back of the newsprint composition where the drawings are adhered. This will create a dark, thick application of graphite, which will serve as "carbon paper" or transfer paper (Fig. 7). Lightly wipe the graphited surface with a folded paper towel to remove excess powdered graphite.

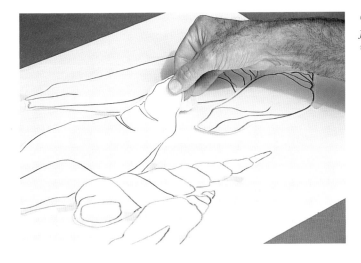

6. Start to move the images around to form the composition. Tape them down when finished.

7. Rub graphite on the back of the drawing and lightly wipe off any excess graphite powder.

4. Using two small pieces of masking tape at the top, attach the newsprint that has the contour drawings on top of the sheet of white drawing paper. Trace over the contour drawings so the images are transferred by the graphite powder (Fig. 8) onto the white paper. You can use colored pencil to trace. Be careful not to press too hard, which would create embossed lines. If embossed lines show up, they can be corrected later. Check the progress of the transfer by lifting the newsprint paper and looking to see that the lines are transferring to the white drawing paper. If they are not, press harder or add more 6B graphite lines to the back of the newsprint. The transferred lines shouldn't be too dark, but should be dark enough to see.

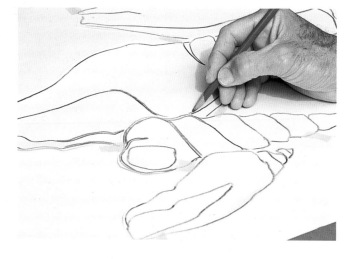

8. Trace the drawing on the white paper. A colored pencil could be used for tracing so you can easily see which lines have already been traced.

AVOIDING EMBOSSED LINES

Embossed lines are formed during the tracing process if the pressure on the pencil is too heavy, especially if you are working on a soft undersurface. When the shading is applied later on, the embossed line will appear as a white line, which can be visually distracting. To avoid this, use masking tape at the top of the laid-out sketch page and hinge together the sketch page and the white paper underneath. This will prevent the top page from moving and will allow the top sheet to be lifted so you can check to be sure you are not pressing too hard when tracing. Rub a finger over the transferred area to check for possible indented lines. If embossed lines have occurred, they can be removed by placing the sharp tip of a 2HB pencil in each line and shading the line to match the values around it.

Since this book is intended for people at various levels of training, the following is offered as a guide for moving through the creative process of organizing a composition. Although there are several other principles of composition, only four are introduced in this activity. See the composition chapter for more details.

CENTER OF INTEREST: The center of interest is the area that first attracts the viewer's attention in the composition. People have discovered that on a rectangular surface, certain areas are naturally "stronger" or attract attention more, if everything else is equal. These areas can be located by using the concept of the division of thirds. Divide your paper into thirds horizontally and vertically with lightly ruled lines (Fig. C-1). You will find that the center of interest of a good composition almost always is found in one of the four areas where the lines cross (Figs. C-2 to C-4). Keep this in mind when you plan a composition.

DIRECTIONAL MOVEMENT: Locating the most important parts of your subject matter in the shape of a triangle can help in creating a visual flow through a composition. By placing subject matter at each point of the triangle, you help the viewer's eyes move among the objects. The triangle helps to reinforce the directional movement in the composition (Figs. C-5 and C-6).

A FEW WORDS ABOUT COMPOSITION

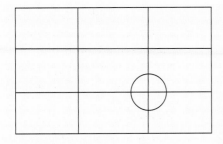

C-1. The horizontal division of thirds.

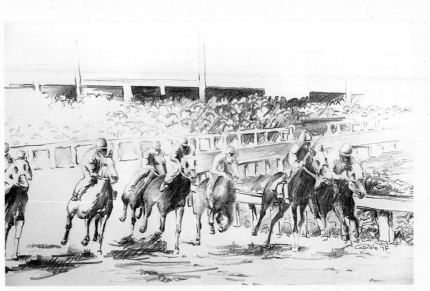

C-2. Drawing of racing horses by Robert Capitolo; graphite. The division of thirds was used to emphasize the center of interest in this drawing.

C-3. The vertical division of thirds.

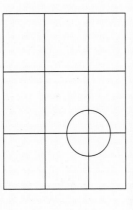

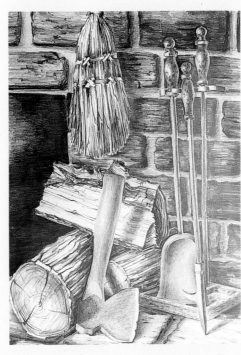

C-4. Fireplace by Robert Capitolo, graphite. The vertical division of thirds was used to emphasize the center of interest.

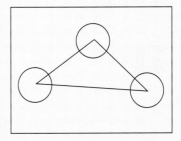

C-5. A horizontal triangle with three interest areas.

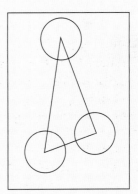

C-6. A vertical triangle with three interest areas.

BALANCE: Creating a feeling of visual equality helps to avoid overloading one part of the composition. Using the concept of the triangle not only assists in creating directional movement, but can also help to create balance. One large object can create a feeling of visual equality with a small and a medium-sized object.

HARMONY AND CONTRAST: To increase the interest in your composition, harmony and contrast are important. Repeating similar units is needed to create a cohesive work, but some variation in the work also is needed to offer visual change and interest. Some elements that can be changed are the size, shape, texture, line, level of detail, and value of things in the composition.

Practicing Smudge Shading

materials

paper towel (for use as a blending
 tool)
white drawing paper, 6″ × 9″
 (15 × 23 cm), heavyweight
your preliminary sketch/composition
 from Activity 2
objects you used for your
 preliminary composition
drawing pencil, 6B
graphite stick, 6B
kneaded rubber eraser or white
 eraser
ruler
masking tape

1 Using your 6B pencil, create a
value scale of 6 steps or more from
darkest to lightest. Try to make each
pair of steps an equal distance apart.
Creating a value scale allows you to
recognize the range of shading possi-
ble and gives you practice in shading
and in increasing your shading
"vocabulary." Do this on the side of
your 6″ × 9″ paper.

2 Using the preliminary compo-
sition on newsprint you made in
Activity 2, transfer the drawing of
the main center of interest by trac-
ing it onto the 6″ × 9″ white draw-
ing paper. You can use the same
tracing method as for Activity 2
(Fig. 9).

3 Before proceeding, using the
6B pencil, try two shading techniques
on a separate paper. First, with the
pencil only, create an even tonal value
and a gradation, getting evenly
darker. Second, use both the pencil
and a blending tool such as a folded
paper towel (Fig. 10). For the second
method, use the pencil to create an
even tonal value; then rub on top of
that area with the paper towel. Try to
form a gradation of tone by rubbing
the blending tool over the shaded
surface. Then ease up on the pressure
and slide the tool slowly away from
the shaded area. This should produce
a gradual change from dark to light.

4 Before you start practicing
the smudge shading technique on

9. Center of interest area and the value
scale for practicing smudge shading.

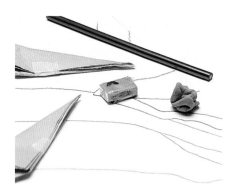

10. Folded paper towels for use as
blending tools.

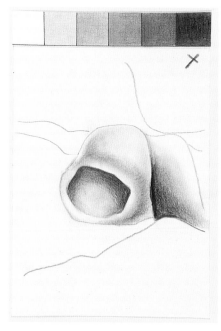

11. Practice smudge shading using all of
the values from the value scale.

the 6″ × 9″ transferred drawing, place a small "x" in the margin on the left or right side of the paper. This will indicate the direction of the imagined light source or of an actual light source. Place the actual object you used as the source of your contour drawing on the table, so that you can look at it for reference. Try to arrange it so you are looking at it from the same angle you saw it from for your contour drawing. Start shading one section of the drawing. Shade the dark side of the object with the pencil, but not to its final darkness. Use the blending tool to create a gradation from this shaded area toward the light source (Fig. 11). Leave the top portion of the object white and use the blending tool to create an edge, working from the lightest side of the object. Do not add outlines on the form. There are no outlines on natural forms, so they should not appear in realistic shading. The edges are implied. We can see where they are because of the shading. (The outlines in our sketches are darker so you can see them in the book.)

HOW TO PREVENT SMEARING

To prevent unwanted smearing or smudging of the drawing, place a small piece of paper under the palm of your drawing hand. This paper must stay still while the shading is being done. If it moves around, it can still smear the drawing. If erasing is necessary, use a kneaded rubber eraser.

activity 4

Creating the Finished Smudge-Shaded Drawing

materials

objects from which you did your contour drawings
white drawing paper, 18″ × 24″ (46 × 61 cm), heavyweight
newsprint paper, extra sheets, 18″ × 24″ (46 × 61 cm)
newsprint paper, 5″ × 5″ (12 × 12 cm)
pencil, 6B
kneaded rubber eraser
blending tool (stump or rolled-up paper towel)

1 Place the 18″ × 24″ white drawing paper in front of you on the table. The contour drawings already were transferred to it in Activity 2. If the tabletop is too textured or too hard, place three blank sheets of newsprint paper under the white paper to act as a bed or cushion during the shading process.

2 Set out your drawing objects so you can use them for reference, arranged as you have them in your composition.

3 Try to set up your work area so you have a light source from one direction, either daylight or artificial light (but be aware that daylight changes in the course of the day). The light could be in the same location as it was on the 6″ × 9″ practice sheet. You could start the shading in the same area on which you practiced earlier (Activity 3), since this will be familiar, or in another area that is a center of interest. Try to think about your darkest darks and work towards the lighter tones. Cast shadows may be your darkest darks. Think about your composition and strengthen the areas in the center of interest with more detail. Work on nearby areas (Fig. 12). The kneaded

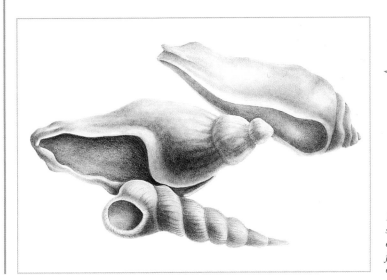

12. Continue shading more areas that are joined to the center of interest.

eraser is a good tool to use for lightening an area and creating highlights. Use the kneaded eraser in a dabbing or pushing down motion on an area. Avoid rubbing with it; don't use it like a conventional eraser. To clean the kneaded eraser, simply stretch it and fold it over until the outside is clean.

4 A cast shadow is a shadow that is cast by one object on another object or surface. When shading cast shadows, keep in mind that the areas where an object touches the table are darkest. The tones become lighter as the shadow moves away from the object on the table. There are no outlines around cast shadows. The edges are soft, blurred areas (Figs. 13 and 14). Figure 15 shows the completed drawing.

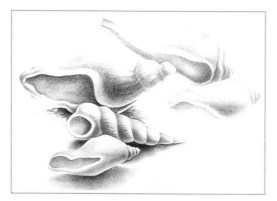

13. Start adding the cast shadows on the tabletop.

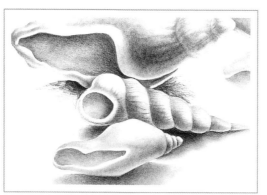

14. This detail shows the beginning line shading of a cast shadow, as well as a cast shadow that has been blended to a gradation.

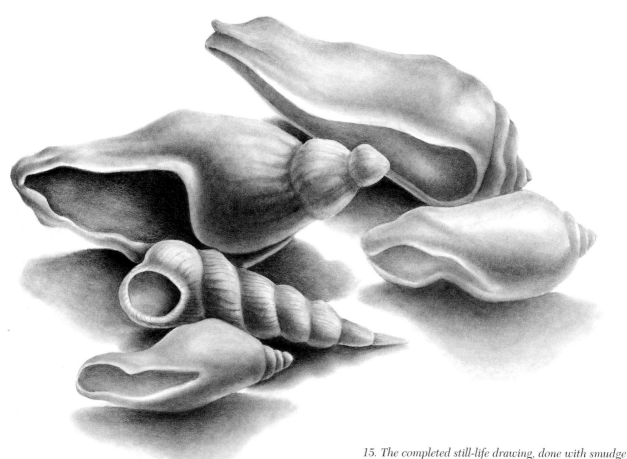

15. The completed still-life drawing, done with smudge shading, by Robert Capitolo; graphite.

Ink Drawing with
Hatch and Cross-Hatch Shading

Here we'll be drawing and shading in ink. The shading will be created by a series of closely spaced lines.

Using a self-contained pen, you will avoid the constant need to replenish the ink and the risk of spilling the ink. Three pens were used for this technique: 005, 01, and 05. Anything smaller than 005 might be too fine. The choice between a 01 and 05 is personal. Anything over 05 might be too thick, making it difficult to draw.

The surfaces of papers and boards can be made by either a hot-pressed or cold-pressed process, as discussed in the materials chapter. The board to use for the ink technique in this project is 100% rag surface, cold-pressed illustration board with a thick gauge. It will absorb the ink nicely and can be erased. An electric eraser with a slight grit to it is very helpful. It can remove unwanted ink marks, as long as the ink has not penetrated the surface too deeply. Use an erasing shield to help control the area to be erased.

Creating a Sketch

materials

pencil, 2HB
newsprint paper, 18″ × 24″
 (46 × 61 cm)
white eraser
subject matter (garlic, other food
 items, etc.)

1 In rendering a sketch, the image starts with a series of loosely drawn lines that show and define the edge of the form. Look for the basic geometric forms that comprise the

1. A head of garlic was our subject matter.

VOCABULARY

HATCH SHADING: a series of closely placed parallel lines used for shading.

CROSS-HATCH SHADING: a series of closely placed parallel lines, overlapped by other lines done at different angles for shading.

VALUE PATTERN: a dark/light design that travels through the composition.

object: cube, sphere, cone, etc. (Fig. 2). Build upon the basic form, refining it as you depict the object. Reduce the many starting lines to create one clean defining line for the object.

2 You have compositional choices. You can either draw separate items, cut them out, and arrange them, or draw your composition from objects that have been previously arranged in a still life. You could also create a visually exciting drawing from one item, like a head of garlic. For this

2. To start the preliminary sketch, look for basic geometric forms that comprise the subject matter.

composition, format size, value range, and unshaded areas are very important.

If you are going to draw several objects, cut them out and arrange them. Refer to the principles of composition that were previously discussed (Project 1, Smudge Shading). The same concept applies if you plan to create your own still life. Even if one item (garlic) is used, you still must consider the center of interest, directional movement, value pattern, harmony/contrast, and balance.

3 Create your preliminary drawing on newsprint (Fig. 3). By doing this and transferring the drawing to the illustration board, you will avoid all the erasures on your final format.

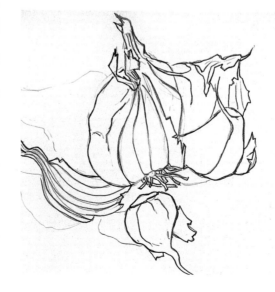

3. The preliminary sketch has been reduced to a single line drawing, which will make it easier to trace.

Practicing Cross-Hatch Shading with Ink

materials

illustration board, cold-pressed (thick weight)

pens (self-contained): 005, 01, and 05

white eraser (with slight grit)

electric eraser (optional)

eraser shield

pencil, 2HB

ruler

preliminary sketch

4. Pens, eraser, electric eraser, eraser shield, and ruler.

1 Create a gradation from dark to middle to light values (Fig. 5). On a 4″ × 6″ (10 × 15 cm) piece of illustration board, draw a small rectangle. Keep the board in a vertical position. In this rectangle, plan to keep your first set of diagonal lines about ³⁄₈″ (1 cm) long at about a 45 degree angle, using the 05 pen. Start at the top with closely spaced parallel lines. As you start to move down, make the cross-hatch lines lighter by using the 01 pen and spacing the lines a little farther apart.

Finally, when making the lightest gradation, use the 005 pen and space the lines even farther apart and make them shorter. Be precise in starting and stopping the lines, and vary the length of the lines slightly.

2 Shade a small sphere on a scrap piece of illustration board, using all five qualities of proper shading as previously discussed on page 16: light/dark side, reflective light, cast shadow, highlight, and back shading (Fig. 6).

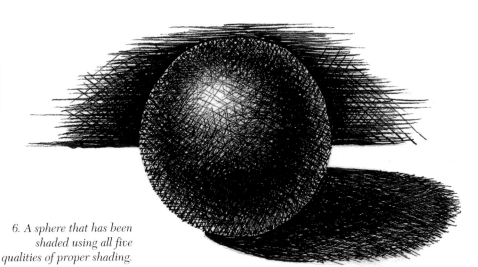

6. A sphere that has been shaded using all five qualities of proper shading.

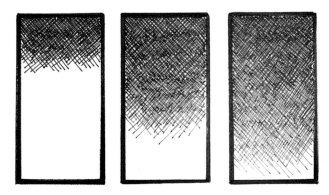

5. On the left, a 05 pen was used to created the dark value area. To make a smooth gradation while moving down the rectangle, it is important to vary the length of the lines. In the middle rectangle a transition has been made from a dark value to a middle value by using a 01 pen and spacing the lines a little farther apart. In the rectangle on the right, a 005 pen was used to create the lightest area. The length of the lines in all three rectangles has been varied.

Drawing and Shading Your Composition

materials

illustration board, cold-pressed
 (thick weight)
pens (self-contained): 005, 01, and
 05
white eraser with a slight grit
electric eraser (optional)
erasing shield
masking tape
pencil, 2HB
graphite stick, 6B
preliminary sketch
newsprint
paper towel

1 preliminary drawing with the 6B graphite stick. Lightly wipe off any excess graphite dust.

2 Attach the preliminary drawing on the illustration board and transfer it. Do not press too hard; you may create embossed lines.

3 It may be helpful to shade your preliminary sketch so that you will become more familiar with the dark and light values (Fig. 7). This will assist you when it is time to start your final ink drawing.

4 It is time to start—but how and where? A given area, in a cross-hatch drawing, is composed of the cumulative effect of a number of small marks. Start with your 01 pen with ⅜″ (1 cm) long, closely placed parallel lines. Start with a small area in one of the darkest places of the work. Build the values up slowly

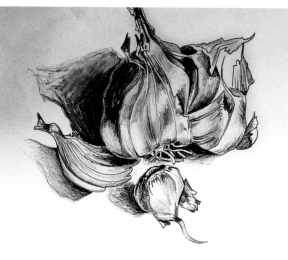

7. *The preliminary drawing has been shaded with graphite.*

8. *The gradation in the shadow area.*

9. *Another detail showing the gradation in the shadow area.*

10. Move slowly around the composition as you work. Refer often to your resources (in this case, the garlic). The creative process of shading may require you to omit, change, or add to your work during the time that you are shading.

11. The smallest areas demand full concentration and refined application of ink.

from dark to light (Fig. 8). You can always add more strokes to make an area darker, especially by using the 05 pen. It is easier to make a gradation from dark to light (Fig. 9). Form the edges of extreme value contrasts by starting the shading on the edge of the dark side and then pull the pen into the intended dark area. This repetition will form the edge. Be sure to leave white areas. You need to create the full value range in your artwork. If there are too many similar middle values, the work will be washed out with no visual impact. An extreme contrast of a dark area next to a light area will aid in establishing the center of interest (Fig. 10). Keep a small sheet of newsprint under your shading hand to prevent dirt and oil from getting on your board. Always make sure that you are not working on top of a newly inked area. The darkest darks may be cast shadows on the table (Figs. 10 and 11).

5 The electric eraser can be used, with the erasing shield to control the area to be erased, to remove unwanted marks. It is best if you can wait until you are finished with your drawing before using the electric eraser as it raises and disturbs the fibers on the board. This can affect the next application of ink, which may "bleed" in that specific area.

6 Finish your ink cross-hatch drawing (Fig. 12).

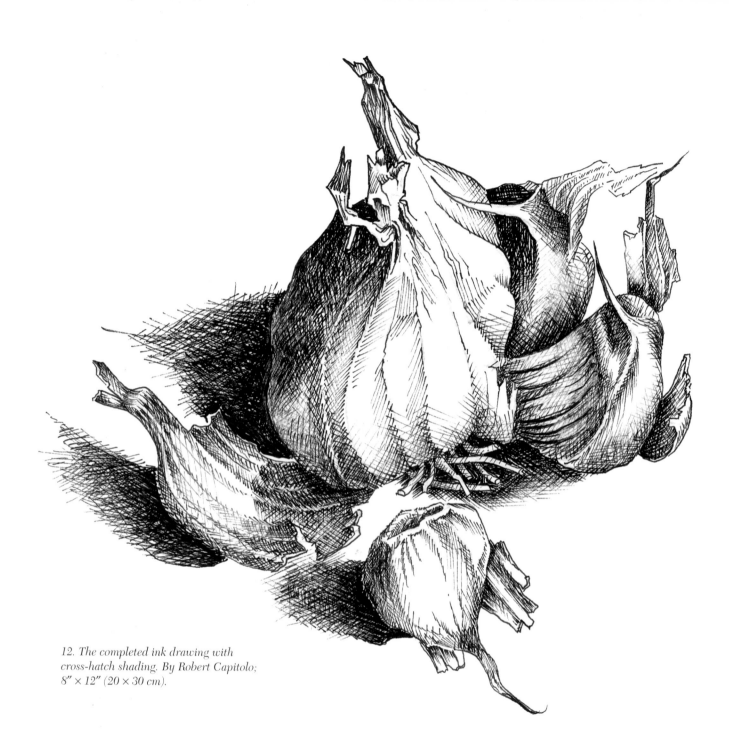

12. The completed ink drawing with
cross-hatch shading. By Robert Capitolo;
8″ × 12″ (20 × 30 cm).

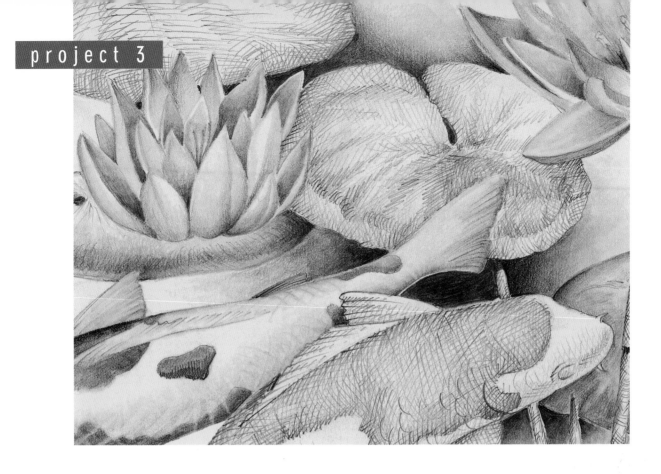

Montage Composition with Cross-Hatch and Smudge Shading

This project will show you how to make a composition by grouping more than one image. We will explore how smooth shading and cross-hatching can complement each other. A montage can use many different sizes of image with a single theme, which need not make visual sense in real space as the objects would in a still-life setting. This makes a montage an interesting composition. Start with a theme or subject and find many images that you like. You may find images in books and photographs or you may draw them from life. I like fish ponds and koi carp, so I started to collect images of fish and plants that are found in and around ponds. I looked for interesting images that had good shapes and good lighting.

Creating a Composition of Several Images

materials

many images of the subject you
 chose
large newsprint paper
scissors
pencils: 2HB and colored pencil
erasers: white, kneaded rubber
masking tape
graphite stick, 6B
tracing paper, 18" × 24" (46 × 61 cm)
paper towel
illustration board, 18" × 24"
 (46 × 61 cm)

1 After collecting various images for the artwork, choose some that can be used vertically and some that can be used horizontally in your composition. The more variety you have in their sizes, the better it will be. Next try to rank the images in order of preference. What image is the most important to you, and how important do you want it to be to the composition?

2 Make a contour sketch of each subject you have chosen on a piece of newsprint (Fig. 1). Remember that you can enlarge or reduce an image if you want to. Do a little shading on the sketches so that you can see where the light source would be to help you in your shading later. Do as many as you can, at least three different sketches.

3 After completing the contour sketches, look at the drawings and select them in order of preference from the most important or impressive to the least important. Cut them out of the newsprint so that only a small margin is left around the drawing (Fig. 2).

1. Using resource photos, make many contour sketches on newsprint. Here Ken is drawing some koi.

2. Cut around your sketches for easy placement later.

3

5

4

6

3 to 6. Thumbnail sketches made from looking at resource images. Figure 5 was the composition that was chosen.

VOCABULARY

MONTAGE: a composition made up of portions of existing images, arranged so they join, overlap, or blend with one another. The images may have a common thread or relationship.

THUMBNAIL SKETCHES: small sketches, only a few inches (5 or 7 cm) wide and tall, which are quickly done by an artist as aids to planning a composition.

VISUAL MOVEMENT: the path your eyes take when looking at a composition, created by the artist's knowledge of composition.

4 Make thumbnail sketches to help you plan your composition. Look at your resource images and quickly make several thumbnail sketches, using the images to create these small compositions, varying their sizes as needed. By looking at your resource images, you can see if you have more vertical objects than horizontal; this would be a factor in your choice of format. If you have more vertical pieces than horizontal ones, it would be better to use a vertical format. Use the division of thirds (see the basic concepts chapter) as a guide to placing the images. Have some images overlapping and some near each other. Each thumbnail sketch should be quickly done and can be rough—not necessarily perfectly proportioned. Review your thumbnails and choose the best one to use as a guide in placing the sketches for your actual composition (Figs. 3 to 6).

53

5 Take a sheet of 18″ × 24″ (46 × 61 cm) tracing paper and fold the paper into thirds in both directions; then unfold to reveal creased lines and 9 cells. This gives you guidelines for the rule of thirds, as you had for your thumbnails. Place your first contour sketch under the tracing paper and trace it completely onto the tracing paper (Fig. 7) in the same position as it is on the thumbnail. Use the folded thirds to guide you. Remove that sketch and place the second sketch under the tracing paper, positioned correctly relative to the first sketch. The tracing paper allows you to see the images and how they relate to each other (Fig. 8).

6 Continue to place and trace more sketches and move them nearer to—or even overlapping—the first two sketches if this aids the flow of the drawing. Each sketch is added and placed to balance the others that are there. The sketches can be moved and changed many times until you are totally satisfied with the arrangement. You can use outlines and borders for a background shape to enhance the composition if you like (Fig. 9).

7 When you have finished tracing all the shapes you want to their correct positions, you can transfer the composition onto a good white illustration board or drawing paper. Use a graphite stick to rub the back of the tracing paper with the images on it, until it is dark; then lightly rub the graphite in with a soft paper towel. Hinge the newsprint onto the illustration board with tape at the top so that you can lift your tracing paper sketch to see your progress on the illustration board as you trace over the images on the tracing paper. Use colored pencil so you can easily see which lines you traced. Do not press too hard because in tracing, dents will be created that will be seen in the final drawing. Refer to Project 1 on Smudge Shading for details of tracing an image.

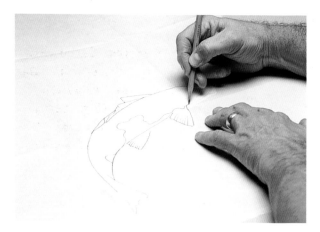

7. Completely trace the first contour sketch onto the tracing paper in the correct position.

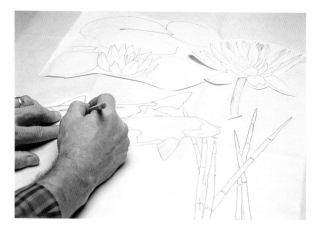

8. Continue tracing contour sketches until you have created your composition.

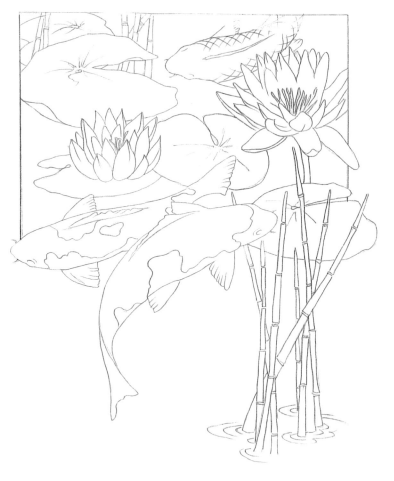

9. The final composition on tracing paper.

Practicing Gradation of Value with Lines

materials

pencil, 2HB
scrap drawing paper

1 We have talked about smudge shading and how it can create a gradual change of values from dark to light by using many tools such as paper towels, stumps (tortillons), and cotton balls. The light areas are soft and show no line quality with smudge shading technique. Cross-hatch shading is the opposite of gradual shading technique. With cross-hatch, we will use line density to create a slow change of values. The more lines in an area, the darker it becomes.

2 To make a gradation of values with cross-hatched lines, start with a group of lines that are the same length and go in the same direction. This group of lines creates a value or tone of gray. The next set of lines will cross the first group of lines and will be longer, so that the first lines are overlapped. The third set of overlapped lines continues past them. Each successive set of lines should be of different lengths and cross at different angles, so that the original start of the drawing will have many layers and the last area applied will have only one set of lines (Fig. 10). Every set of lines applied will make that area darker.

We use the term cross-hatching to describe this because the lines must cross each other to create the darker tone and keep the gradation even. To make a simple gradation, you must have at least three different angles of lines. There is no limit to the layers and direction that the lines can take. The amount of cross-hatch buildup is determined by the darkness needed and what you want to accomplish with the lines. The lines can be curved or less rigidly applied (see the detail photos of the current project).

3 Parallel lines can also be used in making a gradation of values. The closer the lines are together, the darker they become (Fig. 11). All the lines slant in the same direction. These can be spaced very tightly to

10. Cross-hatch gradation of values using 5 steps. This method uses different directions (angles) and lengths of line: The top is the simplest, with one set of lines. As you read down, more layers of cross-hatching are added.

11. A gradation using parallel lines.

create a dark area; some crossing will occur.

4 To learn any kind of drawing skill, practice and build confidence in your ability to make lines. Look at the values of dark and light to be sure that as you add lines they will fill in the areas smoothly. Avoid a stiff, hard application of lines for each of the layers; instead be quick and light with your pencil strokes. Make a few squares on a scrap piece of drawing paper so you can practice making a gradation of values from each corner of the square (Fig. 12). Start with a small series of lines; then cross them with a series that is longer, repeating this in many directions. Try to make a smooth gradation of values toward the center. Do this on all four corners and leave a light area in the middle.

12. A practice square for learning how to make cross-hatch gradations.

Making the Final Drawing

materials

pencils: 2HB, ebony black
kneaded eraser
stumps (tortillons)
paper towels
cotton balls/cotton pads
workable fixative

1 Use the original resource images from which you made your sketches as a guide to the dark and light areas for your drawing. These will help you to see details and textures and let you make a more realistic drawing. It is very helpful to study the dark and light areas before you begin the cross-hatch shading.

2 Begin to draw in the center of interest area. Sometimes you can make this area darker and more finished, leaving the outer areas softer. The center of interest is a special area and should be given the most

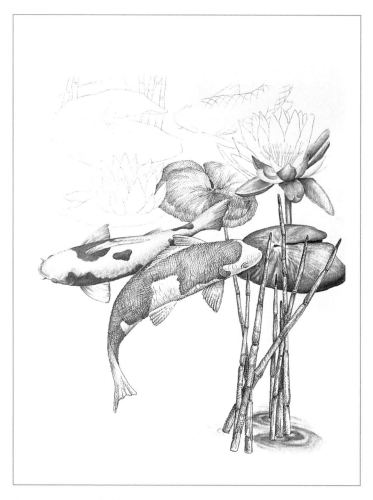

13. Drawing, halfway completed, showing the center of interest.

attention (Fig. 13). Use a piece of paper as a place to rest your hand, so that you will not smear the drawing as you work.

3 Plan out areas in which you will shade with cross-hatch technique and areas that will be using a smooth, smudge-shading technique. Try to use the cross-hatching technique in at least three areas of the composition to give it balance and harmony. The cross-hatching will look different and therefore it is important to choose its placement carefully. Vary the placement of the cross-hatched items so the lines move through the entire design.

4 To prevent smearing of your drawing, spray your drawing with a workable fixative as you work. Use a very light application, holding the

spray can about 14″ (36 cm) from the piece. Spray in a circular motion to avoid concentrating too much spray in one area. This can be done many times and will keep the drawing clean, but before you spray, make sure you are not going to erase anything, because it will not erase after you use the fixative.

5 Create a value pattern of dark and light areas that work through the composition so that the eye is moving throughout the format (Fig. 14). Background areas (negative space) can be used to back-shade certain parts and create dark places that will lead your eye through the composition.

6 The resulting montage should be a pleasing composition that uses a variety of drawing techniques and a variety of objects of different sizes and shapes. A strong vertical and horizontal visual movement is essential to a harmonious and balanced composition, increasing the rhythm through each image. The drawing should be well rendered with different drawing techniques to break up the overall character of the drawing. Keep the cross-hatching areas quick and fresh. We include a closeup so you can see the details (Fig. 15). Figure 16 shows the finished work. Once you master the technique, you may want to try one in ink and in colored pencils or paint.

14. The value pattern of the negative space (dark areas), showing a directional movement through the format. The numbers show where the cross-hatch drawing will be done.

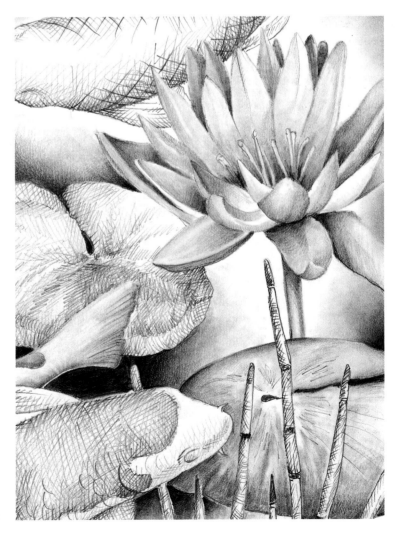

15. Closeup of the final drawing.

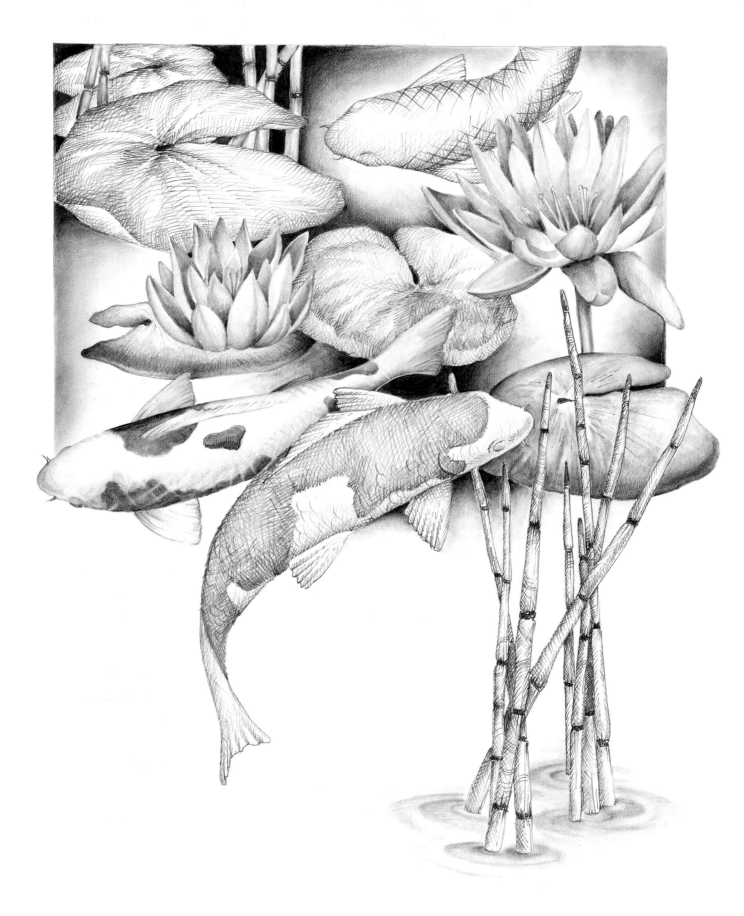

16. The finished work, by Ken Schwab, done in graphite pencil, 15″ × 18″ (38 × 46 cm).

Random Line Shading with Gesso

Here more randomly placed line shading occurs, in contrast to the more controlled hatching technique used in the montage project. The gesso underpainting in the present project creates a surface that affects the quality of the lines, which can lend an interesting appearance to the work.

For your first drawing on gesso, I suggest that you avoid portraits and compositions composed of many small objects. Closeup renderings of the subject matter will work the best. Some examples could be a closeup of a frog on a twig among a tangle of reeds, or a closeup of a bird in an apple tree with large leaves, with branches and apples to balance the composition. These examples should only suggest the size of the subject matter in relation to the format. A small format might work best for this technique: 10″ × 12″ or 8″ × 13″ (25 × 30 cm or 20 × 33 cm).

Once you work with this technique, you will discover that some subjects work better than others. The random line application of the gesso under-painting may conflict with your intended shading. The lines may go in the wrong direction or they may create too dark an area during the shading process. This experience will help you in your next attempt.

Creating a Sketch

materials

pencil, 2HB
newsprint paper
white eraser, with a slight grit
subject matter (actual and/or
 photographs)

1 Create your preliminary sketch (Fig. 1) on the newsprint. I suggest a format between 8″ × 13″ and 10″ × 15″ (20 × 33 and 25 × 38 cm).

2 Refine your sketch to one clean line. This will make it easier to transfer on the gessoed board (Fig. 2).

1. A preliminary sketch, still in rough form.

2. The preliminary sketch refined to one clean line.

VOCABULARY

GESSO: a white acrylic paint of thick texture that is used as a ground or for underpainting.

VISUAL IMPACT: the intrinsic quality in a finished artwork that demands attention.

PHOTOS AS A SOURCE OF SUBJECT MATTER

P-1. The sun is striking these rocks at a 45 degree angle.

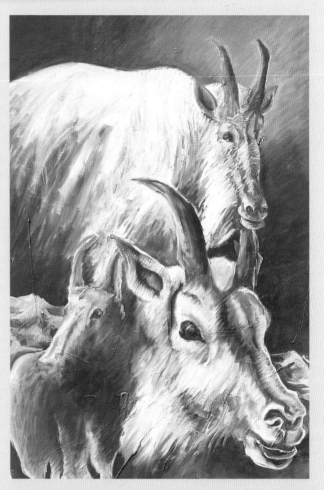

P-2. In this oil painting by Robert Capitolo, light strikes the animals at 45 degrees.

The subject matter in photographs can be an inspiration for the drawing. Magazines with single themes (birds, endangered animals, Africa, etc.) have good closeup views of possible subject matter. The following are suggestions to keep your creative spirit alive when using photographs:

1. Do not merely reproduce a photograph. Take parts of several photographs and create your own composition. Think about foreground (things in front or closer to you), middle ground (the area that is overlapped by the foreground) and background (the most distant area).

2. Use photography for a resource and information, but use your interpretation and imagination for your artwork.

3. Make your selection from photos with good light sources. The closer the angle of light hitting the subject matter is to 45 degrees, the easier it will be for you to decide how to shade your drawing

(Fig. P-1). This light will help to create a good visual impact in your work (Fig. P-2). The light from an early morning or late afternoon sun is at a 45 degree angle. The closer the light source becomes to straight overhead, the more the subject is completely flooded with light. In this straight-overhead light, there are few contrasts of light and dark. With too many middle grays, the work will be washed out.

Preparing the Gesso Board

materials

illustration board, heavy-gauge,
 the size of your sketch
gesso, good quality
mixing stick
newsprint paper
newspaper
pumice (optional; available in
 hardware stores)
fan brushes
aluminum pie tin
rubbing alcohol
sponge

The thickness of the illustration board helps it to resist curling after the gesso has been applied.

1 Place a sheet of newspaper under the illustration board to protect the work surface. You will be pulling the brush beyond the edge of the board.

2 When opening the container of gesso for the first time, you may find it too thin for this technique. Certain brands of gesso are thicker than others. I prefer using a thick consistency of gesso. If the gesso is too thin, pour some in an aluminum pie tin and leave it uncovered a little while, allowing for evaporation. Another way to thicken and add texture to the gesso is to add pumice. This will give a slightly rougher surface.

3 I have saved old fan brushes and have used them over and over for this technique. I have found that these are the best for controlling the texture. If the fan brush is new, touch it lightly, only on the tip of the brush, in the gesso, and allow the paint to dry. This will aid in leaving the necessary textured brushstrokes (Fig. 3).

4 Apply the gesso on the illustration board by picking up a generous amount of gesso and painting it on (Fig. 4). Leaving the paint a little thick, work on a 2″ × 5″ (5 × 13 cm) area at a time. As you apply the gesso, make 1″ to 1½″ (2.5 to 3 cm) short, random, choppy brushstrokes. Keep the pressure on the brush, so that the brush lines will appear behind each stroke. Do not create repeated strokes that would make a pattern. The textured brush lines need to appear for this technique to work. The entire board's surface needs to be covered with gesso. A slight change of color will indicate if an area was missed. The board can be touched up after the first coat has dried.

5 Set the board aside to dry. It may slightly curl from the moisture of the gesso. This can easily be resolved. After the gesso has dried, take a wet sponge and moisten the back side of the board. Place it on a sheet of newsprint. With another sheet of clean newsprint paper on top, place sufficient weight on top and leave it on for several hours. This process can be repeated as needed. Rubbing alcohol will clean dried gesso from the brush bristles.

3. A new fan brush has a small amount of dried gesso on the tip.

4. Load up the brush with gesso and leave a slight thickness on the board as it is applied. The brushstrokes need to show.

Transferring the Preliminary Drawing to the Gesso Board

materials
preliminary drawing
illustration board with gesso on it
paper towel
graphite stick, 6B
pencils: 2HB and colored pencil
masking tape
kneaded rubber eraser
gesso
fan brush

1 Coat the back side of the preliminary drawing with graphite from a 6B graphite stick.

2 It is very important that you lightly rub the extra graphite dust off the back of the sketch with a paper towel (Fig. 6). Otherwise, the gesso will pick it up easily, smudging the gesso surface. You cannot erase the gesso surface. This will be explained later.

3 Tape the preliminary drawing on the gesso board and trace the drawing. You could use a colored pencil to do the tracing. Since the preliminary drawing was rendered in graphite, when you trace with a colored pencil, it will be easier to see what lines you have already traced.

4 Untape the preliminary drawing from the board. If there are any graphite smudges, do not erase. It is next to impossible to erase anything from a gesso drawing. To eliminate unwanted marks and get the surface back to white, follow these steps:

a. Using a kneaded eraser, press down on the undesired area and lift off the eraser. Move to a clean part of the eraser to repeat this process. Failure to do this will result in pressing the graphite on the eraser back onto the board. Any other type of eraser used in a rubbing manner will smudge your work.

b. Look closely to see the direction of the gesso lines.

c. Dip your fan brush in the container of gesso and paint over the unwanted area in a thin application of gesso. Move the fan brush in the same direction that the original application had. This first coat will appear gray. Let it dry. Repeat that many thin coats as necessary to return the area to a white surface.

5. Materials for Activity 3, transferring the drawing.

6. To avoid smudging the gesso board, wipe off the excess graphite dust before tracing the drawing.

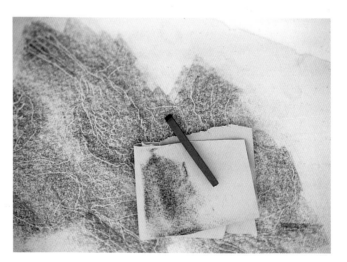

Shading the Drawing

materials

preliminary sketch drawing
(on newsprint)
pencil, 2HB
newsprint
gesso
fan brush
gessoed illustration board with
tracing
photos or other subject matter
tracing paper

7. Materials for Activity 4.
Your subject matter could be
photos also.

There are several important things to do before you start shading on the gesso board.

1 The most important is to shade in your preliminary drawing, at least in the center of interest area. It is helpful to know the darkness of the various values before you start on the final board, especially since you cannot erase on the gesso.

2 Create a good directional movement and value pattern by leaving the four corners of the board white (Fig. 8). Have the area of white vary in each corner (Fig. 9). Allow some of the white or very light values to travel through the dark-valued area. By shading the area with dark values around the center of interest area, the eye will go to the focal point with greater control. Figures 10 and 11 are other examples in which the corners are white.

8. The shaded area creates a
value pattern, allowing the eye to
travel through the composition.

9. The shaded area here
(background) will be white,
including all four corners.

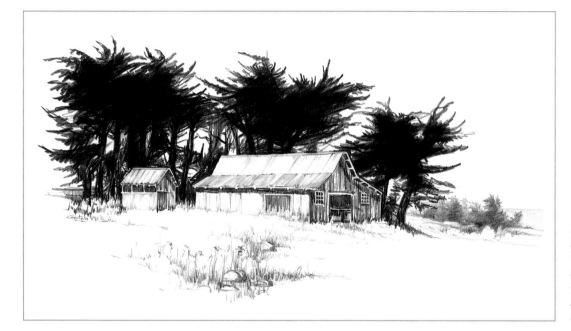

10. Graphite drawing on paper by Robert Capitolo. The four corners are left white, which allows for a strong horizontal directional movement.

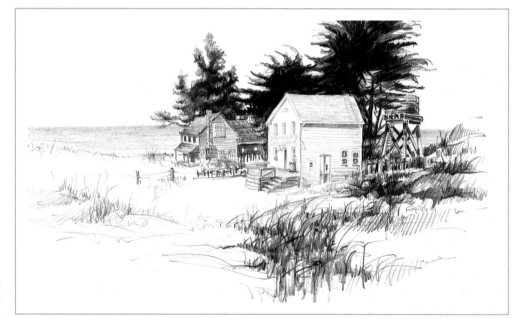

11. Another graphite drawing on paper by Robert Capitolo, in which the four corners are white.

3 the actual gesso board, use a very sharp 2HB pencil and place a small sheet of newsprint under the palm of your hand. Instead of holding the pencil as if you were writing a note, hold it farther back toward the eraser (Fig. 12). Keep the position of the pencil, in relation to the board, at about a 33 degree angle, and lightly shade.

12. Holding the pencil for light shading.

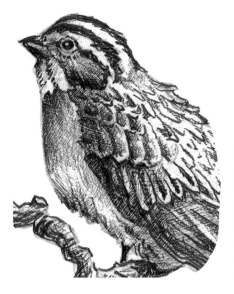

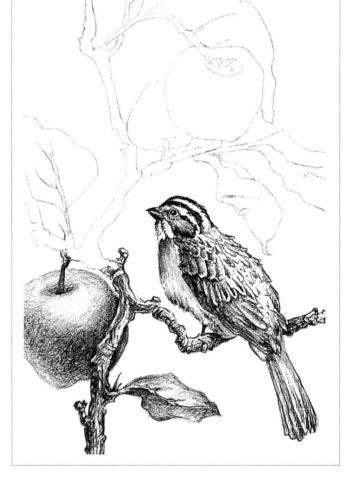

13. Closeup showing the center of interest area, where this drawing was started. It has more detail, which will help draw greater attention to the area.

4 The high ridges of the brushed gesso will catch the sharp pencil tip and record the graphite very rapidly. You can always make an area darker. The entire shading process will go at a remarkable speed. You will find that making a gradation to a light area requires almost no pressure on the pencil. You almost let the weight of the pencil drag over the surface in a controlled motion. When a dark to black area is required, hold the pencil very close to the tip and shade. Depending on the darkness, you may have to shade down in the grooves of the brushstrokes with a sharp-tipped pencil (Fig. 13).

5 To avoid unwanted smudges on the board, keep a small sheet of newsprint under the palm of your shading hand when working. The newsprint must not slide over the gesso surface, because it could smudge the graphite.

6 After the center of interest is shaded, work on other areas (Figs. 14 and 15). Be sure to maintain the same visual intensity (Fig. 16). Keep working until you finish your gesso drawing. Figure 17 shows my finished drawing.

14. After the center of interest was shaded, the artist moved away from the center of interest to other areas.

15. Another area that was shaded after the center of interest.

16. Maintain the same visual intensity as you work in other areas.

7 When you complete your rendering, spray the work with fixative. Use several light applications, allowing the surface to dry each time.

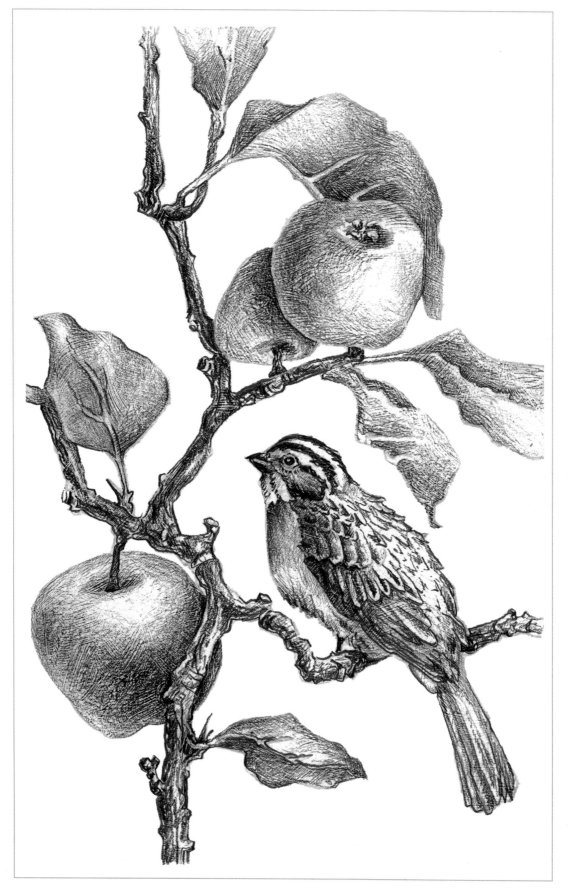

17. The final graphite drawing on gesso, 8″ × 12½″ (20 × 32 cm), by Robert Capitolo.

Charcoal Portrait on Toned Paper

In this drawing we will be using toned paper. This is a great way to draw portraits. The value of the paper supplies the middle tones. The white charcoal will produce highlights and other light values; the black charcoal will produce the shades. This technique is good for any subject where there is a good value contrast.

For this drawing, choose a photograph or other image that has a good range of values from black to white with many tones of gray in between. A live model posed in good lighting also could be used. The highlights are important. A high highlight is a sparkle or shine on a face, usually on and around the eyes, nose, or cheekbones. It reflects light back to you in the brightest form. It is easier to work with a black-and-white photo than a color photo, as it is not necessary to translate the colors into values of gray. As you get more experience, you can try working with a color photo also. If you are taking your own photos, have a strong source of light to create shade and highlight areas. When choosing a portrait photo, it is nice to have an expression on the face that shows character.

If you are working with a live model, you can adjust the light and the pose of the model so you get a good range of values. Light the face from the side to give it a dark and light side.

There are three standard portrait views. One is a front view, which is completely symmetrical; the face is not turned at all, as in Fig. 1. The second view is a profile, as seen in Fig. 2. The third view is the three-quarters view, somewhere between the first two positions (Fig. 3). The three-quarters view is the most commonly used. Because part of the face is turned away, it is more interesting than the other two views.

1. A photo with a full frontal view of the face. It is easy to see the proportions from this view.

VOCABULARY

TONES: grays and grayed values of colors.

HIGHLIGHT: area of reflection where light hits an object directly, resulting in the lightest value on the subject.

SHADE: the dark side of a form, usually on the side opposite the highlight.

REFLECTED LIGHT: light that bounces off other objects. It may lighten parts of the shade area.

BACK SHADING: the area that separates the edge of a subject from the background. Back shading can be lighter or darker than the paper when you use toned paper.

2. A photo almost in profile or side view.

3. An example of the three-quarters view of the face. Part of the face is turned away and the view is from slightly above. The features on the nearer side of the face look bigger because that side is closer to the viewer (foreshortening effects). Light coming from one side puts part of the head and face in shadow.

Working on the Sketch

materials

photos or live model
newsprint paper
pencil, 2HB
kneaded rubber eraser
sandpaper

We start the drawing by making a sketch of the shape of the head in pencil. Use your measuring method and the basic proportions to help you. Refer to the front-view proportions of the head on page 71, but be aware that if the head is turned or if you are looking from above or below, there will be foreshortening and the measurements won't be the same as from the full-face view.

2 After a sketch of the head shape is complete, find the center line of the face. This will be different for each view. Lightly mark the center line and find the halfway point between the top and the bottom (tip of chin) of the head shape.

3 If you extend the halfway point horizontally, it is the approximate placement line for the eyes (eye line) if you are looking at the full face. Measure each eye in relation to the width of the face, and place the eyes as they appear. Place the tip of the nose somewhere on the center line you started with originally. If the face is facing fully towards you, the tip of the nose will be halfway between the eye line and the tip of the chin. If you are seeing a full frontal view, an eye is about one-fifth the width of the face, and there is one eye width between the eyes. The distance from the outer edge of the eye to the edge of the face also is about one eye's width. Depending on your view, this may or may not be true for your resource image, so measure to be sure where to place the eyes. If you are working with a three-quarters view, one eye looks bigger than the other because it is closer to you. Draw what you see.

4 Find the location of the space between the lips—the line between the upper and lower lip. Mark this with a short line.

5 Lightly sketch the outlines or contours of the eyes, noticing the shape and how open the eyelids are (Fig. 4). Look for the high point and the low point in the contour of the eyes. Keep looking, measuring, and observing to sketch in the eyes. Be sure to include a highlight in the eyes. Eyebrows are arched and are above the eye line. The thickness and shape of eyebrows depend on the individual.

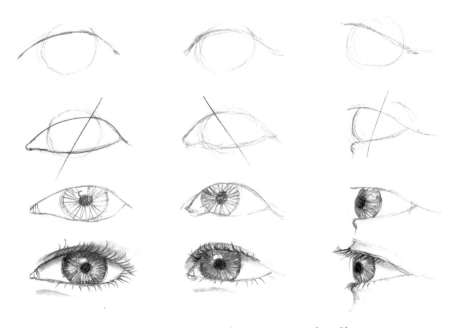

4. Eyes drawn from all three views: front, three-quarters, and profile.

BASIC PROPORTIONS OF THE FACE

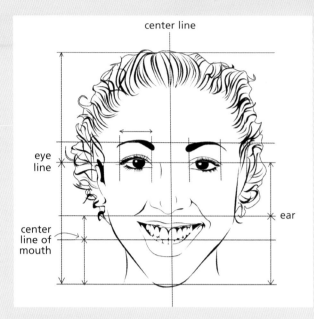

F-1. Diagram of the front view of a face, showing the basic proportions of the face.

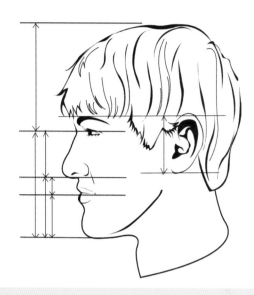

F-3. Profile showing the hair and ear as well as proportions. The contour is very important in this view.

Although each face is unique, there are certain proportions that are more or less universal that will give you guidelines for making a basic sketch. The dimensions below are general guidelines to follow if you are seeing the full face. You can then modify your sketch to match the unique person you are drawing. Study Figure F-1 as you read this text:

- The head has an egg shape and, from a full-face view, if divided by a center line down the middle of the nose, is bilaterally symmetrical.
- From the top of the head to the middle of the eyes (the eye line) is about half the full height from the top of the head to the bottom of the chin.
- The ears usually run the length from the height of the eyebrow to the bottom of the nose.
- The distance from the bridge of the nose (between the eyebrows) to the tip of the nose is about the same as the distance from the bottom of the chin up to the tip of the nose.
- The center line of the mouth is about one-third of the distance up from the tip of the chin to the eye line.
- The bridge of the nose between the eyes is usually one eye wide. The width of the face is about 5 eyes wide.

All proportions can be verified by you by measurement, using your pencil as a measuring tool. Hold your pencil between thumb and forefinger an inch or two (5 or 7 cm) from the point. Extend your pencil horizontally in front of you with your arm straight, close one eye, and use the distance from the pencil point to your thumb on the tool as a unit of measurement (Fig. F-2). Measure across and down with your pencil to see what is lined up with each feature, and rough in your sketch as you go.

From the side view (Figs. 2 and F-3), you can see the location of the ear (starting halfway back on the depth of the skull), as well as the angle of the neck.

F-2. Using a pencil as a measuring tool.

The nose is next. The width of the nose is at least equal to the width between the eyes. Noses can vary in size and change with expression. I like to start with the area at the tip of the nose as a circle and add the nostrils coming off from the bottom of that circle (Fig. 5). Show the edges of the nostrils as half-circles, giving the nostrils some thickness. If the person's head is turned, make measurements and adapt your draw-ing to what you see. Look carefully at the contour along the nose ridge to show how it will blend into the eyebrows.

7 Mouths are simple if they are closed but more challenging if they are open or showing teeth. In the full-face view, you can find the center line of the mouth (where the lips meet) by dividing the distance between the eye line and the chin in three parts and measuring up 1 part from the tip of the chin. We start with a line for the mouth and extend this past the width of the nose. The top of the lip is a heart shape or curved shape, depending on the person. The bottom lip is usually larger and thicker. The mouth is symmetrical. However, if you are doing a three-quarters view or any-thing but a full-face view, you don't see the whole mouth (Fig. 6). Verify

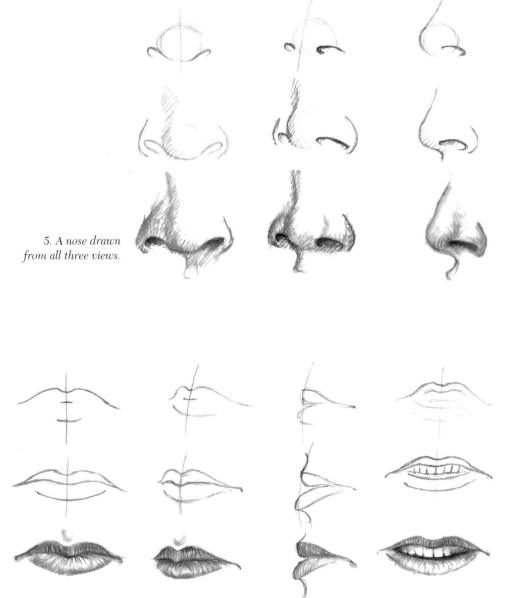

5. A nose drawn from all three views.

6. Mouths from three views as well as an open mouth showing teeth.

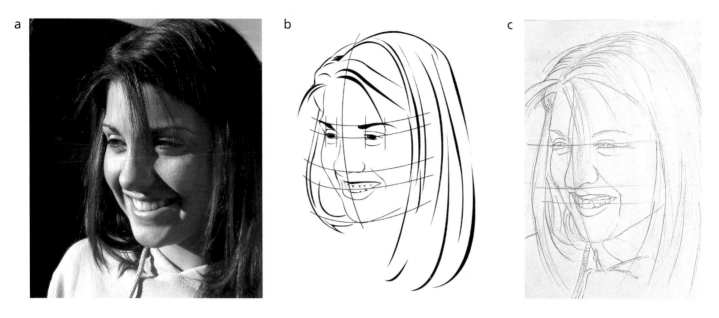

7. a. Photo. b. Lines defining the hair and some measurement lines. c. The finished sketch on newsprint, used to make the final drawing.

the length from the center of the lips (right under the tip of the nose) to the corner by looking at your subject. Open mouths can have lots of teeth. If you see the whole mouth, the teeth probably are symmetrical on either side of the center line of the face. At the middle of the mouth, start with the two front teeth and work out from there. Look for the proportions of teeth to mouth.

8 Ears and the outside contour of the face should be placed next if they are showing. The length of an ear usually is equal to the distance from the top of the eyebrow down to the tip of the nose. If the hair hides the ears, do the hair first and then do however much of the ear shows. All ears have holes and curves in the upper part. The rest is individual. Look for different sizes and shapes of ears and earlobes.

9 The contour of the face shows the cheekbones and chin. If you have a full frontal view, the cheeks are symmetrical; one side is the same as the other. If the head is turned, one side is closer and part is hidden. Measure and draw what you see. The cheekbones and shape of the chin are important in defining the face.

10 The hair will make your portrait look finished. How the hair falls helps define the individual's appearance. Hair is usually in clumps or large shapes that can be drawn as a group. Do not try to make a bunch of lines; instead look for the main movements of the hair and large shapes of hair. Figure 7b shows lines defining the hair in the three-quarters portrait, based on Figure 3.

11 When the sketch is complete, go over all the areas to make any

improvements there that will make it look more like your subject. Figure 7c shows my sketch.

USING SANDPAPER TO SHARPEN PENCILS

You can use sandpaper to keep your charcoal pencils sharp. Just spin the tip over the sandpaper, holding the pencil at a low angle. This will sharpen just the tip of the pencil so you get a smaller line without having to sharpen the pencil in a sharpener. Only sharpen the tip this way to get small lines; use a regular sharpener when it becomes very dull and flat.

Transferring the Sketch and Completing the Drawing

materials

sketch on newsprint from Activity 1
extra pieces of newsprint paper
black pastel
white charcoal pencil
black charcoal pencil
toned paper with a middle value
stumps (tortillons)
kneaded eraser
cotton pads
workable fixative
sandpaper
color pencil for tracing
masking tape

Choose a toned paper that has a middle value between your darkest and lightest areas in the portrait. A middle gray toned paper is very adaptable to most portrait studies. Some will look better with darker papers and some with lighter papers.

2 Transfer the sketch by using black pastel on the back of the newsprint paper with the sketch and rubbing the pastel in with a soft tissue or paper towel. Black pastel will be visible on the drawing paper and will be erasable later. Do not rub too much pastel off. Tape the middle-tone paper and the sketch paper down to your board, with the sketch paper on top, and use a colored pencil to trace over the sketch outlines. This will put the image lightly onto the toned paper. Use a very light touch so that you can just barely see the sketch on the toned paper. Do not press too hard when transferring, or you will have too much chalk, it

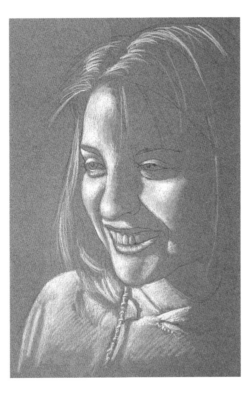

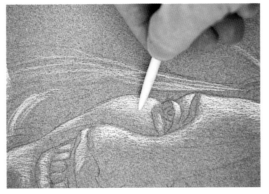

8. White charcoal is applied in the highlight areas, areas of reflected light, and any other areas that you want to look lighter than the toned paper.

9. Soften the charcoal by using a stump or a paper towel.

will be messy, and you will make a dent in the paper.

3 After you remove the sketch, pad the paper with some newsprint underneath the toned paper for a soft feel. Look at the resource image for your drawing and try to see the highest highlights on the face. These usually occur in the eyes, nose,

cheeks, in places where the light has a sparkle or shine. A highlight is not a large area and should not be confused with the light side of the face. Look at all the reflected light areas as well and at anything that is lighter than the tone of the paper.

4 Apply a small amount of white charcoal in the light areas and, with

74

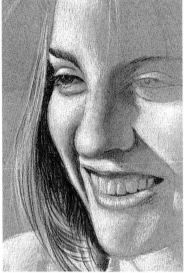

10. Start to add the black charcoal to blend into the toned paper. Try not to mix or overlap into the white charcoal.

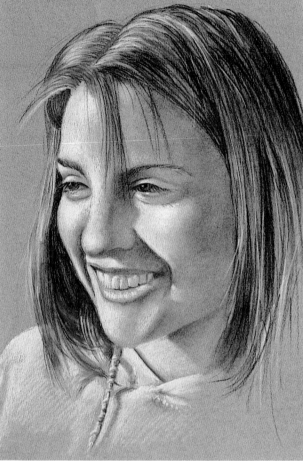

11. Use thick and thin lines for the hair, but be careful not to mix with the white lines.

12. The finished drawing without any change in the background value.

the stump or a paper towel, lightly blend in the edges of the shapes so that they gradually disappear into the tone of the paper (Fig. 8). Do this for all the areas of high highlight. You are trying to blend the white values into the value of the paper. The mid-value paper is the majority of the drawing and the charcoal will just show the extremes of light and dark. When you use the charcoal pencil, rub lightly and gently. Heavy pressure will be hard to control, so build up gradually. The lightest areas will remain intact and their outside edges will be slightly rubbed in to give them a soft grada-

tion to the toned paper. Use a stump or folded paper towel for the best results (Fig. 9).

5 Next you can do the same with the black charcoal pencil (Fig. 10). Find the darkest areas on the portrait. Don't draw outlines, unless they are lines that are required to make the parts have a texture. Add a small amount of charcoal to these areas and use the blending tools to softly blend the charcoal out to the tone of the paper.

6 Try not to mix the black and white together; it is not going to look

good. It will create a muddy gray, which will negate the use of the toned paper (Fig. 11). By leaving the toned paper alone, it will seem as though you are not drawing the entire picture, because you are using the extremes of the value range. It is what you do not draw that is very important. Leave a lot of the toned paper visible (Fig. 12).

7 Spray your drawing with a workable fixative as you work. Use a very light application about 14″ (36 cm) from the work. Spray in a circular motion to avoid concentrating too much spray in one area.

8 When you are finished with drawing the face, look at the background and consider whether it needs a light or dark background to bring out the tones in the face. In the drawing I did, I thought that a light background would improve the look of the tones in the face.

9 You can use white pastel and tracing paper stencils to make a soft background. Trace the outline of the portrait onto tracing paper with a pencil. Cut out the image and place it over the face to protect it. Rub some white pastel onto a scrap piece of paper. Take a cotton pad and rub it into the pastel. Hold the traced outline on the scrap paper down over your portrait, and drag the cotton pad with pastel over the tracing paper, rubbing the pastel on the toned paper to give the background a soft white look (Fig. 13). You can do this same procedure with black pastel to darken an area. This effect is very different from the rest of the picture; it will bring out the middle tones in the face (Fig. 14).

13. Rub the pastel around the tracing paper mask to create a soft, light area in the drawing.

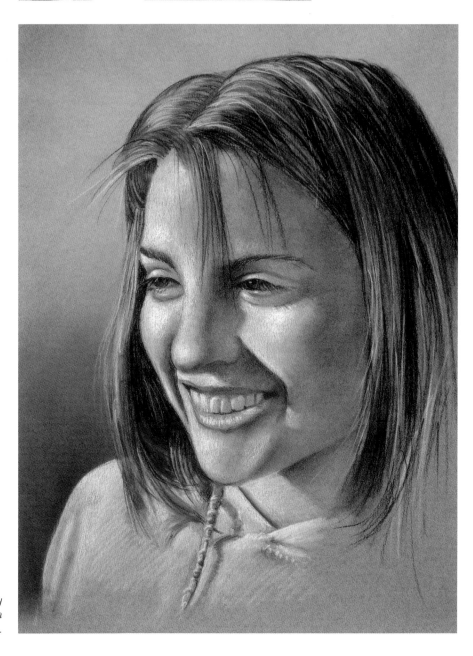

14. The finished charcoal drawing by Ken Schwab with the dark background in place; 9″ × 12″ (23 × 30.5 cm).

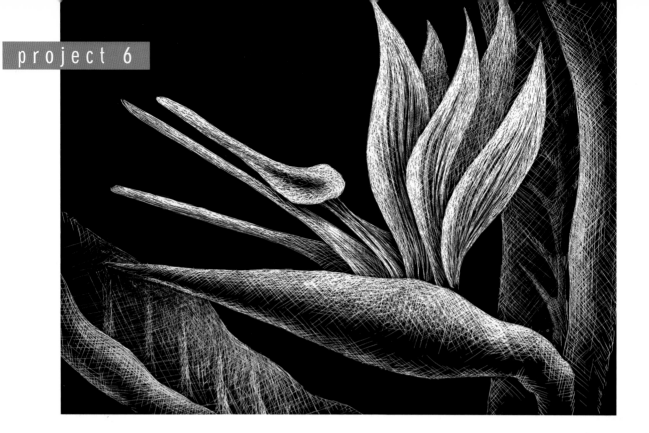

Cross-Hatch Shading on Scratchboard

This project uses cross-hatch shading as we did in the ink drawing project. With scratchboard, however, we start with a black surface and cut lines in it to reveal the white board beneath. The image for your scratchboard can come from photographs, from a drawing, or from observation. We have discussed using and adapting photographs as a resource in Project 5.

Consider the use of images that have a light source striking the subject matter at a 45 degree angle, a strong light that comes from either the top right or top left side of the subject matter. Since you will be working with a black board and scratching away the surface to reveal the white board underneath, you might consider leaving a majority of the composition in a dark value, as we did (Fig. 1). You could use less dramatic lighting in your source photo (Fig. 2) and adapt it to your drawing as needed.

Creating a Drawing

materials

newsprint, 9″ × 12″ (23 × 30.5 cm)

tracing paper, 9″ × 12″
 (23 × 30.5 cm)

pencil, 2HB

eraser

images from books or magazines,
 or actual objects to use as a
 subject

1 Do some thumbnails to plan a good composition. Once you have worked out the concept of your drawing, start to sketch the composition on newsprint. When working with scratchboard, it is easier to work on a small surface, so begin on 9″ × 12″ (23 × 30.5 cm) newsprint. Since you do not know your final format size as you start your sketch, start in the middle of the 9″ × 12″ sheet. A good-sized format is between 5″ × 7″ and 8″ × 10″ (12.5 × 18 and 20 × 25 cm). When the drawing is completed, make a rendering of it on tracing paper (Fig. 3). You will use this later to transfer the image onto the scratchboard.

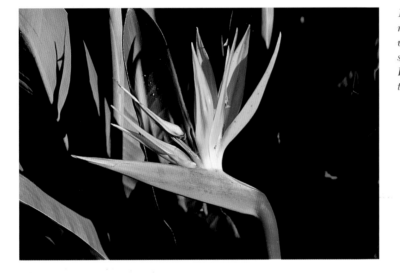

1. The Bird of Paradise flower was the subject matter for this demonstration. The photograph was taken with a strong 45 degree angle light source, and we left the background dark. Dramatic shading in the final work reinforced this concept.

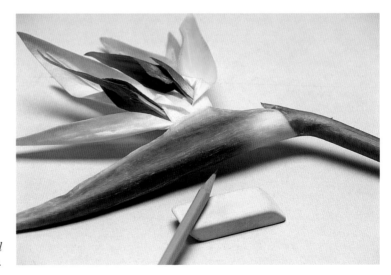

2. Less dramatic lighting also could be used in your resource photo.

2 Next, shade your preliminary drawing before starting the scratch-board process (Fig. 4). This way, you will know the various values and shading for this technique very well. I worked from nature and created my drawing from observation. One leaf in the middle of the drawing was eliminated in the final rendering. During the creative process, you are always open to change. I felt that the leaf would be too much of a distraction.

VOCABULARY

CROSS-HATCH SHADING: a shading technique using a series of overlapping lines.

SCRATCHBOARD: a drawing process that cuts away the black surface of the board to make white lines.

SGRAFFITO: the process of creating incised lines on a surface.

Transferring the Drawing to Scratchboard

materials

pencil, 2HB
preliminary drawing on tracing
 paper from Activity 1
scratchboard, same size as the
 preliminary drawing plus a 1"
 (2.5 cm) border for matting, if
 possible
graphite paper or carbon paper

1 Tape the unshaded tracing paper drawing on the scratchboard. Place carbon paper or graphite paper under the tracing.

2 Trace the preliminary drawing onto the scratchboard. Do not press too hard when transferring. The scratchboard surface is very soft; a heavy-handed transfer will leave an embossed line that cannot be removed. If there is an edge that will eventually have a gradation blending into black, do not trace that edge; carefully refer to your shaded drawing later when working. If the edge is traced, it will leave the carbon deposit on the board, which will show up on the final work.

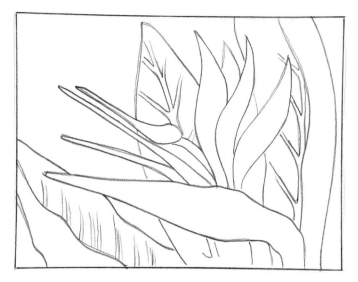

3. From a preliminary sketch, this single-line drawing was done and was transferred to tracing paper.

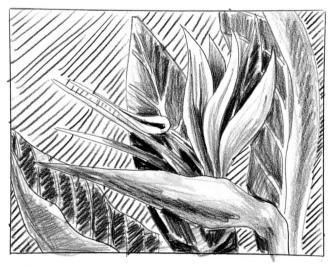

4. The preliminary drawing was shaded, which was of great help when using the cross-hatch shading technique on the final work.

Practicing Scratchboard Technique

materials

scratchboard scrap, 3″ × 4″ (7.5 × 10 cm)
scratchboard cutting tool holder
sgraffito nibs, pointed and curved

1 Scratchboard permits you to make an extremely clean, fine, controlled line. The range of lines, marks, and effects possible with scratchboard is vast. Your ability to use the tool must become second nature, so that you can devote your concentration during the working process to your self-expression. This will take a little practice, since the quality of your work will depend on the refinement and execution of each tool stroke.

2 As with pen-and-ink drawing, a scratchboard line stands by itself, but a grouping of them creates a cumulative effect. Each line or mark is important (Fig. 5).

3 Hold the scratchboard cutting tool holder close to the nib in a position similar to the one for drawing with a pen (Fig. 6). Practice first with the pointed nib. This will produce a range from extremely fine lines to thicker ones, depending on the pressure of the stroke. The nib is

pulled toward you. If the cutting tip slides over the surface without leaving a white line, then one of two situations may be the cause. The tip may not be sharp. Replace the nib with a new one so this will not be a problem. The angle of the cutting tool holder might need to be adjusted, which also could cause sliding. Try moving the holder a little more toward perpendicular to the drawing surface.

4 Start to make a series of lines on a scrap piece of scratchboard 3″ × 4″ (7.5 × 10 cm). Create several ¼″ (6 mm) long parallel lines. We saw previously (in the cross-hatching ink project) that the pen-and-ink technique was composed of a series of

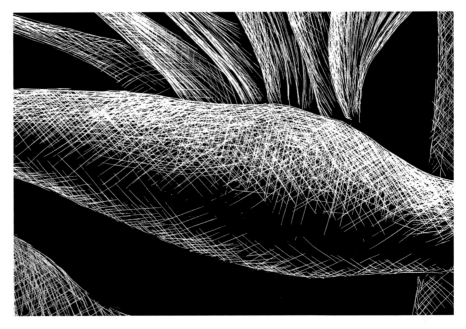

5. This closeup not only shows a quick gradation from light to dark, but how the grouping of cumulative strokes produces the desired effect.

6. Greater control of the scratching tool is achieved if the tool holder is held closer to the nib end of the handle.

black lines. With the scratchboard technique, you will be working with a series of white lines. When starting the scratchboard, you will begin with cross-hatched light lines, let them form a gradation to middle values, and finally blend them into a black value. Your eye will group these areas together, creating a cumulative gradation (Fig. 7). I like to start work in the center of interest area (see Fig. 5). I can control both the degree of value change needed to capture the viewer's attention and the starting point for the composition's directional movement.

5 In addition to cross-hatching, two other pattern effects can be achieved. Stippling is a dot-by-dot application of strokes, almost resembling a picking motion. A hatching series of strokes also can produce a tonal texture.

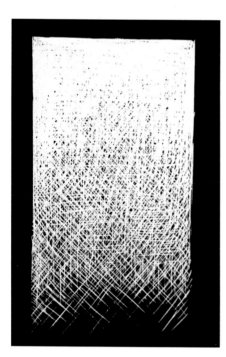

7. *By working on a small scrap piece of scratchboard, become acquainted with cross-hatch and create a gradation of values before you start to work on your final scratchboard drawing.*

activity 4

Executing the Drawing on Scratchboard

materials

scratchboard: 2″ × 3″ (5 × 7 cm) scrap, plus the board for the final drawing
preliminary drawings
resource image of subject
sgraffito nibs, pointed and curved
penholder
newsprint, 5″ × 5″ (12.5 × 12.5 cm)
carbon paper
lacquer spray
India ink
brush
water

1 You may want to practice on a scrap piece of scratchboard. Overlap

8. *Sketch, cutting tools, subject matter, and scratchboard for Activity 4.*

the center of interest area on your sketch onto the 2″ × 3″ (5 × 7 cm) scratchboard and trace it onto the small scratchboard scrap, using carbon paper. Take your shaded preliminary drawing and, using it as a reference, start to work in the lightest area of the center of interest.

2 With a series of strokes, start to cut lines to reveal the lightest value (the white board underneath). Continue to take ¼″ (6 mm) long strokes and try to replicate your shaded preliminary drawing on the scratchboard. As your confidence increases and you feel comfortable with your practice, switch over to

your final scratchboard rendering on the full-size scratchboard. Figures 9 and 10, as well as Fig. 5, show details of the scratchboard lines. In Figure 9, the visual movement leads to the right side of the composition.

3 Always keep a small piece of newsprint under the palm of your drawing hand. This will help avoid unwanted marks, especially oils from your hand, from appearing on the scratchboard surface.

4 If an area appears too light, it can be corrected and darkened. Prepare a mixture of water and India ink. You will need only a small percent of ink in the water. Using a small brush, test the wash solution on an area of light marks on a scrap piece of scratchboard. Build up the darker value slowly. You may not be able to reverse this process. An ink wash also can be used to darken areas. There are three light flower petals in the foreground (Fig. 9). An ink wash was used to darken the two flower petals located behind the front three. This has helped to move the darker petals back in the composition.

5 A line can be corrected on the scratchboard surface by using a very fine brush. With ink, draw the bris-

tles along the unwanted line. Try to keep the overlapping of ink on the original black board to an absolute minimum. The ink outside the line may show up when the work is completed.

6 Figure 11 shows the completed scratchboard. When completely finished with your artwork, spray the surface with a coat of lacquer spray. If the application is too light, the surface may appear unappealing. A nice, glossy surface is preferred. Two light coats may be better than one heavy application. This will eliminate all oily fingerprints.

9. *The visual movement leads to the right side of the composition.*

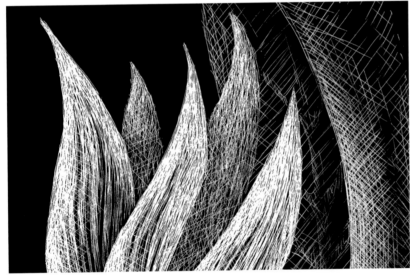

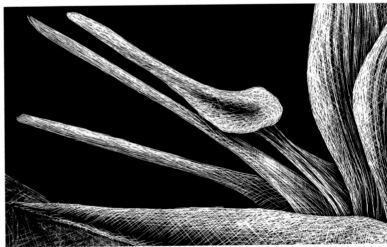

10. The area where a distracting leaf was omitted from the original preliminary sketch.

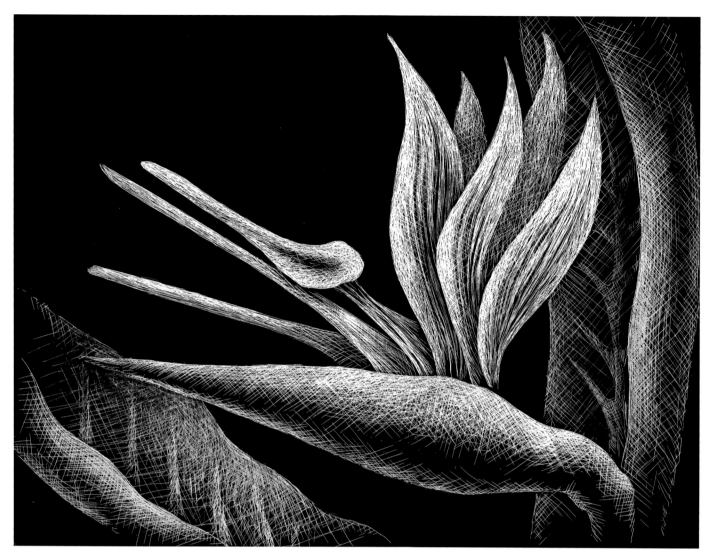

11. The final scratchboard drawing by Robert Capitolo, size 6″ × 8″ (15 × 20 cm)

Nonobjective Design with Colored Pencils

In this project, we'll use part of a photo of yours or one from a magazine, cropped and enlarged, as the basis of a nonobjective design with colored pencils. We'll be using a circular format, but you also can repeat this exercise with any format you like.

The word "nonobjective" means that the artwork does not represent any object, figure, or element in nature in any way. The work uses the elements and principles of design to create interest and structure, rather than relying on real, stylized, or abstracted images. The term nonobjective was first used by the Russian painter Wassily Kandinsky in the early 20th century. There have been many nonobjective art movements, including abstract expressionism (Jackson Pollack, Willem DeKooning), op art (Viktor Vasarely, Yaakov Agam), and De Stijl (Mondrian). There is an enormous range of nonobjective art; however, all nonobjective artists share the common idea that you do not need to depict real objects to have an interesting work of art and a pleasing composition. Understanding and working within the confines of nonobjective design will enhance your understanding of the elements and principles of composition.

We will use a circular viewfinder to help us find a composition; then we'll execute it in colored pencils, learning how to blend them to create soft colors and smooth gradations.

The elements of art that will be important in our work are: color, line, shape, form, texture (implied), value, and proportion. If necessary, review these, as well as the principles of composition, in Chapter 2.

Using a Viewfinder to Choose a Composition

materials

scrap paper
ruling compass
ruler
graphite pencil
craft knife
masking tape
selection of 10 or more photos* or
 color photocopies of photos
tracing paper (optional)

*Unless you use tracing paper or photo-
copies, these photos will get cut up.

1 Use a compass to draw many circles of varying sizes from about 2″ to 5″ (5 to 12.5 cm) across on a piece of paper. Leave a few inches (5 or 7 cm) of paper around each of these circles so that you can have a square of paper around each one. Cut out the circles with the craft knife to make windows that you can use to look at photos in order to find a composition you like (Fig. 3). Make as many viewfinders as you like.

1. Nonobjective work in mixed media by Ken Schwab.

3. Cut out the circles with a craft knife and then cut a rectangular or square frame around each circular opening.

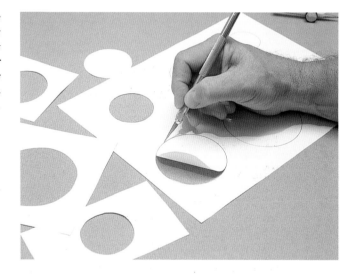

2. Nonobjective work in mixed media by Ken Schwab.

2 Place the circular viewfinder over a magazine image or over your own photo so that the main area of emphasis will fall in an area that follows the division-of-thirds concept (refer to the chapter on composition). Think about the shapes and colors and see if the composition looks pleasing to you. Ask yourself if the composition you have selected meets the criteria of a good composition. This is a creative search. To get another view of your composition, look at it upside down or in the mirror if you're not sure.

3 Use many viewfinders, and choose at least 5 circular compositions that you like from the photos or magazines. Tape each photo behind its viewfinder so you can see how the compositions will look. Then choose the one that you like the best (Fig. 4). Look for colors and shapes that are appealing, have a lot of contrast, and include smooth gradations of color or tone.

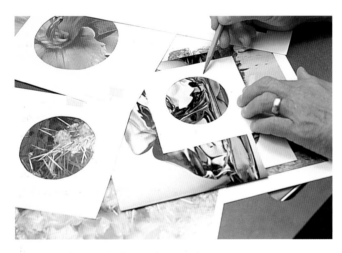

4. Tracing the viewfinder circle on each resource picture.

activity 2

Enlarging the Composition

materials

image in a viewfinder from Activity 1
newsprint, 12″ × 18″ (30 × 45 cm)
ruler
T-square or right triangle
ruling compass
pencil, #2
eraser
tracing paper (optional)
masking tape

5. Drawing a square on the viewfinder around the circle.

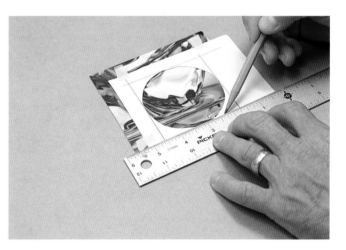

1 After you have chosen the best composition, take this image (we'll call it the resource picture) and enlarge it to whatever size you want.

2 On the viewfinder surrounding your resource picture, draw a square that touches the edge of the circle on each side (Fig. 5) by using a ruler and T-square or right triangle. This square will be used to make a grid,

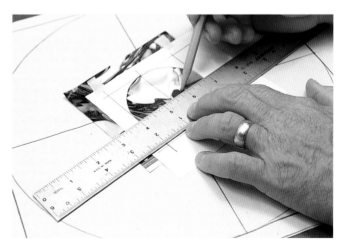

6. Find the halfway points on each side of the square and connect the points to form a grid so the picture is divided in fourths. You can see an enlarged circle in a square, also divided in fourths, on the newsprint paper.

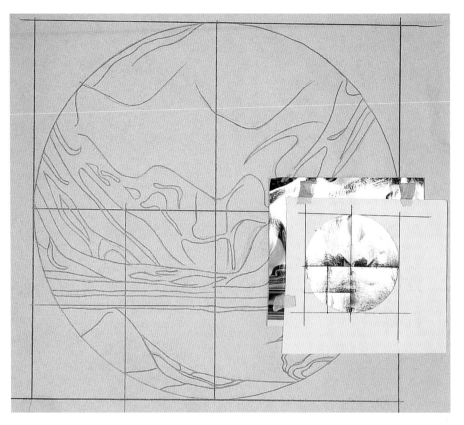

7. Draw the shapes from the resource picture on the enlarged circle. Use the grid lines to help locate and shape them. You can see (lower left) where subdivisions were added to the grid for more accuracy. Finished outlines of the major shapes are seen on the newsprint.

so make it as accurate as possible. Mark the halfway point with a dot on each side of the square around the resource picture (Fig. 6). Connect the dots with a pencil and ruler, drawing the lines over the resource picture as well. This will create a grid of four squares right over your resource picture. If you don't want to write on your resource picture, tape a piece of tracing paper over it first, before you draw your grid.

3 On a piece of newsprint, draw a larger circle to the size you want your final drawing to be. Create a square by drawing lines around this circle, and create a grid on the larger square and circle, as you did on your resource picture. Make sure the lines of the square touch the edge of the circle.

4 Compare the two grids. The smaller one on the resource picture is your guide. The grid lines on the larger circle should be in the same relation to each other as the ones on the smaller circle. Use the grid lines as a guide for drawing the shapes on the larger circle. Notice where each shape touches the lines of the resource picture squares, and use these points as guides on the larger circle. Line by line, draw the shapes on the newsprint, keeping exactly

the same proportions as are seen in the resource picture.

5 If you are having trouble enlarging an area, make some subdivisions within the squares over the problem area on your resource picture. Do the same on the enlarged circle. You will then have more reference points to aid you (Fig. 7).

6 Check the finished enlargement for correct proportions by looking at the two images side by side.

Transferring the Sketch to Drawing Paper

materials

soft graphite stick, 6B

your newsprint sketch from
Activity 2

good quality white drawing paper
(80 lb or more); same size as
newsprint sketch

colored pencil or ballpoint pen for
tracing

masking tape

drawing board or smooth, hard
surface

paper towel

1 To transfer the enlarged sketch onto white drawing paper, rub the 6B graphite stick over the back of the sketch to create a type of carbon paper (Fig. 8). Rub on a good amount; then use a paper towel to lightly wipe off any excess graphite. The graphite will let you trace thin light lines on the good drawing paper so that you will easily transfer your design and have no erasing marks that might result from errors.

2 Use masking tape to tape down the sketch onto the white drawing paper. Hinge it from the back so that you can see what you do as you trace over the sketch. Tape down both of these pieces of paper onto a drawing board or smooth, hard surface.

3 Use a sharp colored pencil or pen to trace over your sketch (Fig. 9). Be sure to avoid tracing the grid lines. Press lightly when tracing. You want to make a light gray mark on the good paper. If you press too hard, it will leave an indented line on your paper that will show up in the drawing.

8. Rub graphite over the back of the sketch.

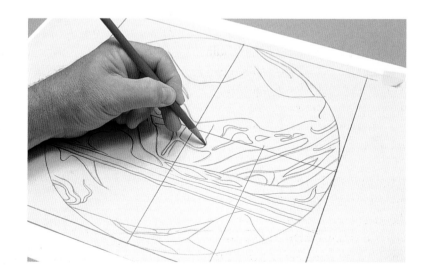

9. Use a colored pencil to trace the sketch onto good drawing paper.

Practice Mixing Colors with Colored Pencils

materials

colored pencils, set of 12 to 24*
blending pencil or stump (optional)
resource photo
extra white scrap paper for
 practice
white eraser

*Should include at least primary,
secondary, and tertiary colors on color
wheel, plus black and white.

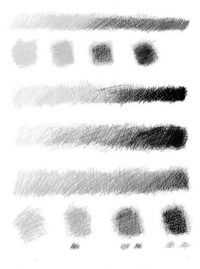

10. Blending colors applied in layers can produce beautiful results.

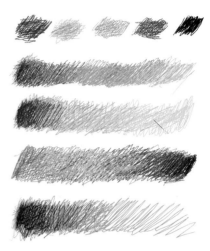

11. Neutrals such as burnt sienna, yellow ochre, burnt umber, and brown can dull other colors.

Here are some practical guidelines for using colored pencils:

■ Mixing colors with colored pencils is different than mixing colors with paint. The secret when mixing with colored pencils is to use layers and to choose the correct color first. For example, to make a light blue-green color that seems to be slightly dull, start with a soft layer of blue, and then add a soft layer of green. Next use a soft layer of white to lighten the color, and blend the layers together. Adding a small layer of a neutral such as brown, raw sienna, or yellow ochre will dull the color down. Then use another layer of white. The white acts like a blending tool, and should not be applied too hard. The result of working with these layers is an interesting new color that will still have a good amount of strength.

■ Erasers usually are not too effective with colored pencils, because the pencils are waxlike and hard to erase. It is much better to blend slowly with layers, making the colors come out perfect the first time. If you need to erase something, use a pink or white eraser that is hard enough to clean the colored pencil. Do not rub too hard or you will tear the paper.

■ Always work on the lighter areas of the drawing first and work toward the darker areas. Lighter colors and white will not be able to change the darker colors if they are applied last (Fig. 10). Pressure is important when mixing with colored pencils. The use of small circles and light pressure will give you smooth coverage and, with enough layers, a strong color.

■ Gradations can be made easily from one color to another by the use of layers and by overlapping the two colors to be used (Figs. 11 and 12). Apply the two colors lightly and softly so that they overlap each other. If you use light pressure, they will merge together. Use the white pencil to blend these layers, and repeat this process until the transition is gradual and complete.

■ Make some value scales from light to dark if you want to expand your color skills (see A Little Color Theory for guidance).

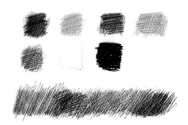

12. Neutral colors are useful in blending with other colors. Below: blue with gray, ochre, and burnt sienna.

89

A LITTLE COLOR THEORY

People have tried over the years to understand the properties of color. Here is a short summary of a way of thinking about color that will help you in mixing colors and will give you more control. Try mixing some combinations of colors on the color wheel and doing samplers. Tag your experiments so you can have them to refer to later on. The discussion below refers to mixing pencils or paint, rather than mixing colors with light.

Any color can be thought of as having three properties: hue, intensity, and value.

Hue
Hue is what we usually mean by the word "color." Red, blue-green, orange, and yellow are some examples of hues. The basic color wheel contains twelve hues of the spectrum, bent around in a circle. We can use this wheel to help us understand some relationships of colors (Fig. C-1).

Primary Triad
The primary colors of pigment are red, yellow, and blue. These colors are basic and cannot be produced by mixing other colors. They are the foundation for color mixing and are the cornerstones of the color wheel. When placed on a color wheel, red, yellow, and blue form a triangle whose points are at equal distances apart. It is from this primary triad that all the remaining colors in the color wheel may be produced (Fig. C-2). Note: The color magenta can't be mixed from the primary colors, but must be purchased separately.

C-1. The color wheel, showing the primary, secondary, and tertiary colors. Complementary colors are across the diameter of the circle from each other.

C-2. The primary triad (red, yellow, and blue).

C-3. Secondary triad of colors (orange, green, and violet).

C-4. Tertiary colors (yellow-green, blue-green, blue-violet, red-violet, red-orange, and orange-yellow) are mixed from a secondary plus its adjacent primary color.

Secondary Triad

The secondary colors are orange, violet, and green. They also form an equilateral triangle on the color wheel. The mixing of two primary colors will produce a secondary color. Orange is made from yellow and red; violet is made from red and blue; green is made from blue and yellow (Fig. C-3).

Tertiary Colors

When a primary and secondary color are mixed, they produce a tertiary color. There are six tertiary colors. Each is located on the color wheel between the primary and secondary color that were combined. For example, blue-green is spaced equally between blue and green. The tertiary colors are: yellow-orange, red-orange, red-violet, blue-violet, blue-green, and yellow-green (Fig. C-4).

Intensity

Intensity refers to the brightness or dullness of a color. To reduce the brightness or intensity of a color, add some of its complement, the color that is located directly across from it on the diameter of the color wheel (Fig. C-5). As more of the complement is added, the hues produced by mixing complements will become duller and duller. Eventually you will have a neutral color, such as gray, burnt sienna, or ochre. It is very useful in drawing with color and in painting to use complementary colors to take away the brightness of a color when you want to produce shadows, show distance, or model a form.

Black and White

Black and white are not considered colors, but are important aids when you draw in color. Black absorbs all light rays and reflects very few. White reflects most light rays. White is the lightest pencil you have. It has the lightest value. Black has the darkest value. When white and black are mixed, they produce tones of gray. If we start with black and mix more and more white with it in steps, and have white as the last step, we will end up with a value scale from dark to light (Fig. C-6).

Values of Colors

When you add black to a color, you are making a shade of that color. Colors get darker and darker as you add more and more black, until the color is almost gone. When you add white to a color, you are making a tint of that color. As you add more and more white to a color, it will become extremely light in value but will never reach a pure white. No color is as light as white or as dark as black. The colors of your pencils have a value built into them. Yellow has a high value (it is very light) and violet has a low value (it is very dark). Blue-green and red-orange are colors of medium value.

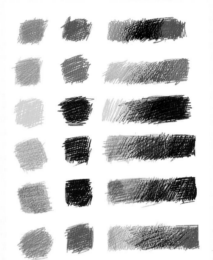

C-5. Complementary colors are located across from each other on the diameter of the color wheel. Their combination produces a range of colors that are less intense. When combined, complements dull each other and eventually create a neutral color, when used in the right proportions.

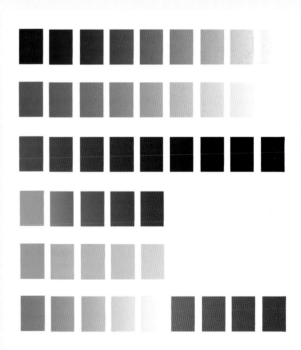

C-6. Tints and shades of blue, orange, green, and purple. If you make a chart of the gradual increments, you have a value scale.

Creating the Final Drawing

materials

colored pencil set
blending pencil or stump
resource picture
enlarged sketch on drawing paper
scrap paper
eraser

1 Looking at your resource picture, study the colors you will have to mix. On a sheet of scrap paper, practice making the colors that you will need for your picture. Learning how to mix them ahead of time will give you confidence and will allow you to experiment and make mistakes on the scrap paper, without harming the final drawing.

2 Take the transferred sketch on good-quality drawing paper you made in Activity 3. Look at your resource picture. Start by applying the lightest colors to the enlarged sketch, where needed. If you need to mix a color for a large area, start with one color covering the entire area. Then apply the second color (Fig. 13). Mixing the entire area as a whole will be better than trying to mix small sections and join them together. Keep the layers thin and use the white pencil to mix colors together.

3 Start adding other colors in the other areas (Fig. 14). As you make parts of your drawing darker, consider areas that need textures and areas that could use lines to enhance the composition (Fig. 15).

4 Keep adding layers until you have created a close a copy of your original photo resource (Fig. 16).

13. *Orange was added to combine with the yellow layer underneath that covered this large area.*

14. *Adding more colors and layers in the drawing.*

15. *Closeup of a textured area with an underlayer of shadows and highlights to give the impression of three-dimensionality.*

16. The finished drawing by Ken Schwab.

Index

About the Authors

Robert Capitolo lives in San Jose, California, with his wife, Rosemary. He attended the San Francisco Art Institute; graduated from St. Mary's College, in Moraga, California; and did his graduate work at San Jose State University.

He taught in the Campbell Union High School District in California for 35 years, where he served as District Art Supervisor and Department Chair at both Campbell High School and Westmont High School. He received the Campbell Union High School District awards for Excellence in Teaching and Excellence in Education, and he also served as a mentor teacher.

Ken Schwab lives in San Jose, California, with his wife, Jeanne. He attended San Jose State University, graduating in 1970, and attained a lifetime Credential in Secondary Education in 1971. Ken has been the art department chairman at Leigh High School and at Del Mar High School for 31 years and has been a mentor teacher for 4 years. He was Teacher of the Year in 1989 and received the Excellence in Teaching Award and Excellence in Education Award in 1987. Ken was a presenter multiple times at the National Art Educators Association Convention.